PRAISE FOR *THE GUARDIAN OF MERCY*

"This book is a great act of compassion, l̶̶̶̶̶̶̶̶̶̶̶̶̶̶̶̶̶̶̶̶̶̶ g̶̶̶̶ ̶̶̶̶̶̶ ̶̶̶̶̶̶̶̶̶̶̶̶̶ celebrates. Thank you for giving us such a gift. . . . That is the power of a real Caravaggio. Sometimes, it simply changes your life. Terence Ward's moving nonfiction book *The Guardian of Mercy* tells the contemporary story of the man who was delegated to watch over *The Seven Acts of Mercy* in the early 1990s, when a new mayor tried to take back the streets from the mafia and make the city appealing to tourists again. In many ways, for Angelo the guard, Caravaggio's Naples differs little from his own. The streets, the very same ancient Greek streets, can still be merciless: the Camorra (the Neapolitan Mafia) and drugs have replaced the regime of the viceroys, and the gulf between wealth and poverty still gapes wide. *The Guardian of Mercy* describes this complicated city with accuracy and empathy, including the colossal disappointments that followed on Naples's brief resurgence in the 1990s. . . . In the preface to *The Guardian of Mercy*, Terence Ward responds to Caravaggio's painting: 'In a city that survives on a knife edge between cruelty and grace, the acts of mercy still resonate today with universal meaning, as relevant now as when the artist brushed his oils onto the canvas four centuries ago.' The painting and its emphatic message of compassion at all costs eventually inspire Angelo to perform his own work of mercy when his life reaches a crisis point. Thus this unusual and poignant book insists that Caravaggio's paintings still call upon us to think and act, not just to look on passively, and in laying down this challenge, as Ward argues, the artist extends a compassionate hand to his viewers across the centuries."
—Ingrid D. Rowland, *New York Review of Books*

"I read the last pages just a few minutes ago. I think it is great, a greathearted gift to our poor, violent, suffering old world. I read with tears in my eyes the whole story of Angelo's struggle and Idanna's heroic good sense and kindness. And, of course, Caravaggio's vision of mercy,

luminous among the shadows, is sorely needed by all of us. And so I give my thanks."

—Wendell Berry, author of *The Unsettling of America*, *A World Lost*, and *Sabbaths: Poems*

"I enjoyed the lively company of *The Guardian of Mercy* while flying across the clouds—for a week in Big Sur, light years away from Princeton—recalling, too, the Italy in which I lived for a year as a student, and loved—have been back only very briefly since, but enough to recall the sights, colors, sounds, delicacies—and the Caravaggio paintings I visited when last in Rome. Thank you for a moving and wonderful account of the power of art and grace with such generosity of spirit!"

—Elaine Pagels, Harrington Professor of Religion, Princeton University and author of *The Gnostic Gospels*, and *Beyond Belief: The Secret Gospel of Thomas*

"*The Guardian of Mercy* is a heartfelt story of a stunning painting and a wondrous city. Terence Ward takes us on a remarkable journey of discovery of Caravaggio's *Seven Acts of Mercy* and along the way illuminates unusual and profound aspects of this long neglected masterpiece."

—Jerry Brown, governor of California

"In its imaginative passages, the book is not only keen to counteract the 'tabloid portrait' of Caravaggio, which highlights his wild-man tendencies, but also to present his work as the bearer of hope, and not merely as a series of apocalyptic historical visions. For the guardian, Esposito, Caravaggio is from the streets but also above them, offering a sense of familiarity and also contact with the transcendent—artistic genius but also human wisdom."

—Leo Robson, *CHRISTIE'S* magazine

"Ecstatic and soul-searching! Written with grace with almost every sentence imparting an epiphany. An electrifying reading experience and a wondrous book on Caravaggio in which Ward stages a powerful encounter with old and contemporary Naples. The great gift of the book is to humanize Caravaggio by endowing him with interiority and by recognizing the

empathy and lessons in mercy at work in *The Seven Acts of Mercy*, which can be regarded as the painter's own solicitation of Mercy for his transgressions. Ward challenges us to undertake soul-work, even if one is a secular reader. Here, reading is an act of empathy and potential readers will read the book with passion and compassion, thereby becoming, in the words of Wallace Stevens, 'necessary angels.'"

—Pellegrino d'Acierno, director of Italian studies and distinguished professor of comparative literature at Hofstra University

"Naples with her multilayered humanity is magnificently evoked, as well as the method of Caravaggio's composition in chiaro scuro, light and shadow. Bravissimo!"

—Raffaele La Capria, author of *Capri and No Longer Capri*, *L'Occhio di Napoli*, and *La Neve del Vesuvio*

"I read with extreme pleasure this wonderful book. There is, need I say, so much written about Caravaggio. I was stunned by Ward's account. This book does everything art writing should do. I am pleased beyond envy."

—David Carrier, author of *A World Art History and its Objects* and *Proust/Warhol: Analytical Philosophy of Art*

"I have just finished this book, which I loved. Having seen the painting last year when I was in Naples, I can't wait to go back and see it through new eyes. It is a truly wonderful story!"

—Natalia Grosvenor, Duchess of Westminster

"Caravaggio's most important work, *The Seven Acts of Mercy*, the altarpiece of the small church called the Pious Mount of Mercy serves as the fulcrum for parallel stories of the artist from the 1600s and the current twenty-first century Neapolitan guardian of this work. In alternate chapters, Terence Ward skillfully reconstructs the ambiguous events of the painter's life while showing how the artwork impacts and affects the emotions and actions of its current caretaker. . . . The most beguiling aspect of this story is viewing the dissection of the painting and inspecting the elaboration of [each act of mercy]."

—*San Francisco Book Review*

"Anyone interested in art and its power to change lives will appreciate this thoughtful work. Ward has written an absorbing account of the powerful experience. The narrative moves back and forth between Caravaggio's time and the present in prose as colorful and compelling as the painting itself."

—*Booklist*

"Strangely compelling . . . a charming departure from the typical narrative of art history. Ward weaves the story of Caravaggio—who was accused of several counts of murder and condemned to a death sentence by the pope, and who eventually died a mysterious, lonely death—with the contemporary story of a guard stationed at Pio Monte della Misericordia."

—*Publishers Weekly*

"A Caravaggio masterpiece on mercy calls to Pope Francis across the centuries. Little wonder that Terence Ward's *The Guardian of Mercy* book is blurbed by the likes of Pete Hamill, the famed chronicler of New York's streets, and that at a recent book party for Ward, Bible scholar Elaine Pagels praised the author and artist ('It's a story of grace,' she said) while William Vendley, head of Religions for Peace International, recounted how much the story moved him. 'Irony is too meek a word for how mercy can penetrate its antithesis,' he said. In San Francisco, California Governor Jerry Brown—a former seminarian—and his wife attended a lecture on the book. 'What Caravaggio does is to bring common men and women into his paintings and make them sacred,' Ward said at the New York book launch. 'Which gives hope for all of us.' The book makes for a compelling narrative, and it also gets to the heart of Caravaggio's appeal—to modern eyes and, perhaps, to Pope Francis and his fans. That's because Caravaggio drew from life, and street life in particular, and his saints are peasants; all of them are baptized but unwashed—even the angels."

—David Gibson, Religion News Service

"Few would wander down the warren of Neapolitan streets to the church the way Terence Ward did one day in 1998. Stunned by what he found in the painting, he was just as captivated by the custodian of the church who stood guard in virtual solitude: Angelo Esposito. After years of

contemplating the image, Esposito had come to appreciate and understand *The Seven Acts of Mercy* in ways few scholars have, and Ward's book brilliantly recounts Esposito's own transformation in relationship to the altarpiece, along with the tangled past and present of Naples itself, and the life of Caravaggio. 'The poet of hope,' as the painting's guardian calls him. Ward's book represents a stroke of providence in that he started it years ago after wandering into the church where the painting has hung for centuries, only to have his laptop with the first manuscript stolen. The delay meant that the publication of *The Guardian of Mercy* coincided with the pope's Jubilee Year of Mercy, and a revolutionary pontificate that would seem to dovetail so easily with Caravaggio's boundary-pushing style. The confluence of developments is also no small irony, and perhaps some posthumous vindication, for an artist who died while desperately seeking mercy from another pope, of an entirely different cast, in an entirely different era."

—National Catholic News Service

"If Pope Francis wanted a single image to illustrate the special Year of Mercy that is the current focus of his ministry and, indeed, the theme at the heart of his pontificate, he could do no better than choosing an underappreciated masterpiece by the thrilling Italian artist known as Caravaggio. In fact, the four-hundred-year-old canvas, an altarpiece in a Naples church titled *The Seven Acts of Mercy*, may represent the perfect combination of the man—or, rather, two men—and the moment: a brilliant painter with a scurrilous reputation who was striving for redemption, and a popular pontiff struggling to make the church more welcoming to outcasts. 'A dramatic convergence has taken place between Pope Francis' teachings and Caravaggio's message,' writes Terence Ward in his new book on the painting, titled *The Guardian of Mercy*."

—*Crux*

"Ward's work offers a refreshing look at a once-forgotten—but now much-celebrated—artistic genius. The author also reveals the subtle and profound ways in which art and life interact. Fascinating reading about a significant artistic figure and his legacy."

—*Kirkus*

THE GUARDIAN OF MERCY

Also by Terence Ward

Searching for Hassan: A Journey to the Heart of Iran

THE GUARDIAN OF MERCY

How an Extraordinary Painting
by Caravaggio Changed an Ordinary Life Today

Terence Ward

Arcade Publishing • New York

First paperback edition 2017

Arcade Publishing books may be purchased in bulk at special discounts for sales promotion, corporate gifts, fund-raising, or educational purposes. Special editions can also be created to specifications. For details, contact the Special Sales Department, Arcade Publishing, 307 West 36th Street, 11th Floor, New York, NY 10018 or arcade@skyhorsepublishing.com.

Arcade Publishing® is a registered trademark of Skyhorse Publishing, Inc.®, a Delaware corporation.

Visit our website at www.arcadepub.com.

10 9 8 7 6 5 4 3 2

Library of Congress Cataloging-in-Publication Data is available on file.

Cover design by Giancarlo Cammerini

Pio Monte Della Misericordia

Print ISBN: 978-1-62872-818-7
Ebook ISBN: 978-1-62872-630-5

Printed in China

To beloved Idanna who pointed the way, and
Richard Seaver who spoke of sliding doors.

"We are beyond the way of the far ships
Here in this coral port,
Farther than the ways of fliers,
Because our destinies have suddenly transported us
Beyond the brim of the enamel world."
—Thomas Merton, *The Landfall*

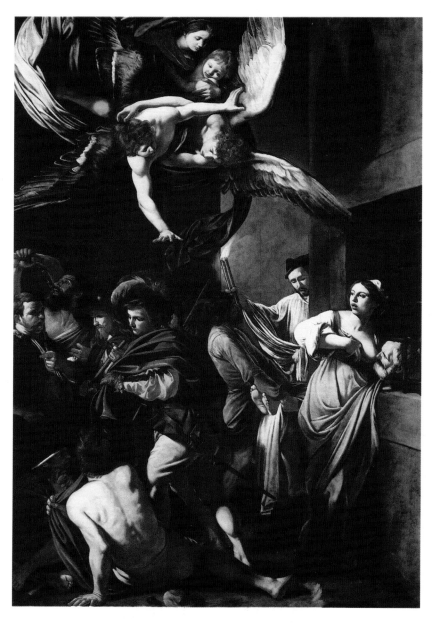

The Seven Acts of Mercy, Caravaggio, 1607

Contents

Author's Note

Lying on our backs, we look up at the night sky.
This is where stories began.
 —*John Berger*, And Our Faces, My Heart, Brief as Photos

I did not seek out this story. This story found me.

I was wandering with Idanna in the back streets of Naples—the Italian city of her grandmother—when we came upon a mysterious painting by Caravaggio. Inside the small, empty, silent church, *The Seven Acts of Mercy* was lit only by a soft glow from the glass skylights of the cupola.

Suddenly, a Neapolitan man chosen to guard this forgotten treasure stepped forward. This humble municipal employee confessed how he had been moved by art for the first time. Unexpectedly, he opened a window for us onto the power of art to enlighten and elevate.

This narrative unfolds through sliding doors, from the guardian's gritty contemporary world to a reconstructed past that imagines Caravaggio's exile from Rome to Naples. There, he creates a painting that offers a fresh take on the perennial acts of mercy—*feeding the hungry, giving water to the thirsty, sheltering the homeless, visiting the prisoner, clothing the naked, healing the sick, and burying the dead.*

In his radical vision, the fugitive artist breaks with tradition, using Neapolitans fresh off the streets as his models, placing them in scenes that defy the religious art of his age.

I am not an art historian. I have tried to draw his character and working methods based on the spare known facts. Caravaggio left behind neither personal effects nor letters.

In a city that survives on a knife edge between cruelty and grace, the acts of mercy still resonate today with universal meaning, as relevant now as when the artist brushed his oils onto the canvas four centuries ago.

* * *

All sacred traditions speak to compassion and human solidarity, which remain the cornerstone of every faith. Their voices echo across great distances and time, chanting the same refrain.

Is it not to share your food with the hungry and to provide the poor wanderer with shelter—when you see the naked, to clothe them, and not to turn away from your own flesh and blood?
 —Isaiah *LVIII, 7*

The Prophet said: "The captive is your brother . . . Since he is at your mercy, ensure that he is fed and clothed as well as you are."
 —Mohammad (570–632), *Hadith*

Every religion has the wholesome core of love, compassion, and good will. The outer shell differs, but give importance to the inner essence and there will be no quarrel. Don't condemn anything, give importance to the essence of every religion, and there will be real peace and harmony.
 —Ashoka (third century BC)

Tzu-kung asked: "Is there a single word which can be a guide to conduct throughout one's life?" The master said, "It is perhaps the word shu. *Do not impose on others what you do not desire for yourself."*
 —Confucius (551–479 BC), *The Annalects XV, 24*

I was hungry and you gave me food, I was thirsty and you gave me drink. I was a stranger and you welcomed me, I was naked and you clothed me. I was sick and you visited me, I was in prison and you came to me.
 —Matthew *25:35–37*

In the New Testament, the acts of mercy are six. Why did Caravaggio paint seven?

Seven has always been a sacred number. Consider the seven days of creation, the seven sisters in the Pleiades, the seven planets visible to the naked eye, and the moon's cycle that is four times seven. The seven colors of the rainbow, the seven neck vertebrae in humans and giraffes, the seven chakras, and the seven years it takes for all the cells in our body to regenerate. The seven strings of Apollo's lyre, the seven Phoenician *kabiris,* the seven horses of Mithra, and the seven days of Passover. The seven valleys of the Baha'i, the seven branches of the menorah, the seven pillars of wisdom, and the seven circlings of the Ka'aba. The seven Sages of the Bamboo Grove, the seven principles of Bushido, the seven hills of Rome, and the seven terraces of Purgatory. The seven heavenly virtues and the seven deadly sins, the seven wonders of the world and the seven ages of Man, and even *The Seven Acts of Mercy* by Caravaggio. And through this strange and breathtaking painting, we are touched by his radical message.

And now a radical pope has stirred a revolution by speaking out for human solidarity and action to battle against what he calls "the globalization of indifference." Pope Francis was hailed *TIME'*s "Person of the Year" in 2013 "for pulling the papacy out of the palace and into the street, for balancing judgment with mercy."

Turning his back on pomp and privilege, he traded down the Papal Mercedes for a scuffed-up Ford, the gold cross for one of simple iron. From the onset, he shocked the public by washing and kissing the foot of a young Muslim girl detained at Casal del Marmo, and then traveling to the southernmost island of Lampedusa to pray for the nameless Arab and African refugees lost at sea and officiate the mass with a wooden chalice made from debris of boats that never reached shore.

Shortly after, he ushered in a surprising new practice. On certain evenings, the Vatican's doors now open up for the homeless. Once welcomed inside, these marginalized souls of Rome are given the opportunity to bathe, have their hair trimmed and even gaze at the Sistine Chapel before leaving.

"The Church is a field hospital on the battleground," he says. "Our first duty is to tend to the wounded." Returning to the spirit of the

original gospel, he offers compassion as his touchstone. "Who am I to judge?" he asks.

A dramatic convergence has taken place between Pope Francis's teachings and Caravaggio's message. A hidden hand is at work. The guardian takes it as a divine sign—a ray of light amid the shadows.

Part 1

IN EXILE

Chapter 1

Into *Mezzogiorno*

Where am I? That is the first question.
—Samuel Beckett, The Unnameable

Outside my window, the swollen Arno surges under Ponte alle Grazie, or Bridge of the Graces. A thick autumn mist slowly wraps its gray shroud over Brunelleschi's cupola. The orange jigsaw of terracotta roofs, domes, towers, spires, pigeon roosts, and satellite dishes soon vanishes from sight. Below, shrewd merchants bargain with foreign shoppers while the few surviving artisans scurry to appointed rounds, heels clicking crisply on stone-laid medieval alleys.

Each day, this once-refined Renaissance city buckles under the weight of mass tourism. Last traces of jewelers, sculptors, artists, and the dying silk trade of Florence lie submerged under a flood of Chinese plastic knockoffs, T-shirts, kebab takeouts, and postcards. Ambulant vendors splay out their wares for countless busloads of travelers. Troupes of Senegalese unfurl sheets laden with fake Prada and Gucci bags. Young Moroccans lay down posters of saccharine landscapes and iconic David with his anatomic wonder. Chinese hawkers dangle counterfeit scarves from their arms. Only in the evening, when the hordes of modern-day Visigoths march back to waiting buses with their cheap trinkets of plunder, only then does the city exhale in relief.

I find myself here, far from the concrete canyons of Manhattan, or the lofty Tehran where I grew up in the days of the Shah, or the anarchy

of Athens where I was based as a cross-cultural consultant for a decade working across the Persian Gulf. All that changed when I met Idanna, whose magnetic voice seized me one evening in the East Village.

We had both been invited to a storytelling dinner at an Iranian friend's flat. Ironically, each of us had separately decided not to go to the gathering, but because of my friend's melodramatic insistence over the phone—he threatened to throw himself from his third-story window—he was able to lure us there.

So I arrived at the candlelit table, and when my turn came I offered the story of Nikos Kazantzakis—author of *Zorba the Greek*—who defied his excommunication by Orthodox priests by carving on his gravestone, perched in the hills above Heraklion, "I hope for nothing, I fear nothing, I am free." When we went around the table, Idanna spoke softly, poetically, and told us about a world where Asia spilled into the green Pacific waters. This island was her home. Struck by her words, I knew that I had to know more. Two years later, we were married on Madison Avenue and 25th Street in Manhattan in the Italianate Appellate Courthouse during a blinding December blizzard that blanketed the city in a white cloak for days.

Here in Italy, I've seen that Idanna carries a wide, cosmopolitan vision that sets her leagues apart from the smug Florentine society that has been feeding off the city's legacy for centuries, instead of preserving the best of the past for the sake of the future. Idanna's style differs dramatically. She chooses to play it low-key, unpretentious and understated.

Peering through the Florentine fog from my desk, I gaze beyond the old cypress in a nearby garden. My gaze falls on two aged figures standing by the bridge staring down at the Arno's rising waters. They do not move and stand transfixed. Decades still have not washed away their memories of November 4, 1966. On that morning, the Great Flood breached the embankments, submerging the city in surging waves and an avalanche of mud.

A burst of rain lashes at the windowpanes. Suddenly I turn to find Idanna standing silently behind me. On winter days like these, a deep melancholy overwhelms her. Her mood changes when the humid chill

seeps through our walls and settles in. And she is not alone. Most of her ever-feuding Guelphs and Ghibellines succumb too. Pushing back her chestnut-hued hair, she sighs.

"My Neapolitan grandmother rarely smiled, but when she was bedridden, I remember that all I had to do was to utter the word *Napoli* and a sudden spark would light up her dark blue eyes."

Though I never met Idanna's grandmother, I know she had two remarkably different sons. Each reflected life's great extremes. Her first, Emilio Pucci, shocked the dreary postwar fashion world and exploded into the sixties with succulent colors—hot pink, turquoise, and lime—in psychedelic prints drawn under a Tuscan sky. Her second son, Puccio, Idanna's father, chose the opposite trajectory. After separating from his young wife, who left for Africa, he closed his palace doors and chose to retreat in solitary seclusion.

So Idanna grew up in a shadowy world, with random bursts of sunlight when her uncle's models preened on the palazzo roof for photo shoots with the Duomo in the background. At eighteen, Uncle Emilio helped her escape to New York, where she worked at Saks for two seasons. But once she understood that fashion was not her path, she set out for Southeast Asia and settled on an Indonesian island. There, she studied Balinese mythology and then wrote a book, *The Epic of Life*, on the ceiling paintings of the ancient Royal Court of Justice of Bali, inspired by an episode from the *Mahabarata* that hauntingly reminded her of Dante's journey into the afterlife.

They say her grandmother, *nonna* Augusta, was a religious woman, quietly severe, who carried the scars of polio from childhood. Yet, sometimes, *nonna* would amuse her granddaughter by recounting memories of a Pompeii-red villa, flooded with magical sunrises when eastern light poured across the great jade bay circling from Sorrento to Posillipo.

Staring out my window into the mist, Idanna's words about her *nonna* linger in the air. "You know, in my family," she says, "the word *Napoli* always conjures up light."

For myself, Naples holds another pocket of illumination, the *Istituto Universitario Orientale*, set in the historic center, which happens to be

one of Europe's finest centers of Near Eastern studies. A leading expert on Persepolis, Adriano Rossi, teaches there. I have urgent need to speak with him about my book on Iran.

"Adriano just wrote," I reply; "he's back at the Orientale."

"Yes, *andiamo,* let's go!" she says without missing a beat.

Early the next morning, we drop by to bid our farewells to Idanna's father, seated behind his desk in the darkened office. A single desk lamp casts its rays downward on his documents. Hearing about our journey south, he raises his eyes and smiles. Puccio was born in Naples.

Speaking in his clipped British accent, he asks me, "You know what they say, old boy?"

"No, tell me, Puccio," I coax him.

"Below Rome, they say, Italy ends and Africa begins."

Then he pauses, negating the words he just uttered. "Terribly mean, all that. Well, don't you listen to them, old boy! I adore Naples. Haven't been back there since the war. It has been such a long time . . ."

Drifting off in thought, he catches himself and waves his finger sternly: "Now, for heaven's sake, don't leave anything in your car!"

I nod respectfully and we turn to leave.

By the time we pass into Umbria, the rain slackens. The fog begins to lift. Rolling hills topped with fortress citadels float lightly above the highway. Soon, the green plains of Sabina surround us. We circle Rome's immense periphery with massive Autogrills offering inedible fast food and quick coffee injections, and enter into the land called *il Mezzo- giorno:* "High Noon." I follow all arrows pointing south to Napoli.

Idanna sleeps as I pass the invisible line that splits one mentality from the other—the work ethic of Milano from the *arrangiarsi* of Naples, or "the art of making do." A look of contentment has settled over her face. Recounting her country's layered culture, she has guided me over the years through the labyrinth of Italian customs, where blunders can often end with final judgment.

By late afternoon, the sky dims with twilight streaks of violet and coral. Our long journey comes to an end on a corniche that hugs the sea-cliffs of Naples in a quarter called Posillipo, from *Pausilypon* in ancient Greek: "respite from worry."

We park in front of Grandmother Augusta's aging villa overlooking the magnificent bay. Scanning to the horizon from this promontory, the gulf spreads out before us. To the west drift the isles of Capri and Ischia. Across the bay, migrations of fishermen sail home like birds in flight with the day's catch. I watch Idanna sigh and fold her hands quietly. Her thick braid falls behind her soft shoulders. I sense that memories of *nonna* are flooding back.

Originally built by the Duke of Frisio in the eighteenth century, the villa was purchased by Idanna's great-grandfather, who gave it his family name: Villa Pavoncelli. Regrettably sold in the seventies by the last heir, it is now an exclusive apartment building. At the entrance stands a doorman in polished uniform. The gate is firmly closed. A sense of pride for its preserved beauty crosses Idanna's face. Giant pines and palms soar from the sloping garden like silent sentinels. She stares at the grand verandas that descend toward the private beach.

"There!" Her hand points down to a white sand cove. "That's where my father and my uncle played each summer as children." She holds the moment briefly. Then it all fades away with the last light.

Further up the cliffs, we arrive at Paola Caròla's home. An old friend of Idanna, she welcomes us into her world filled with bohemian sensibility. Now in her seventh decade, she still exudes a magnetism that is the touchstone of all muses. Her admirers include a collection of writers and artists: Arthur Koestler, Gregor von Rezzori, Raffaele La Capria, and Alberto Giacometti. On her bureau stands her bust by Giacometti, along with an autographed portrait of beloved Neapolitan playwright Eduardo de Filippo, who stares out seductively with his smoky eyes.

Paola first discovered her bohemian side in Paris after she divorced her wealthy elderly Armenian husband, a great art collector. She had met Monsieur Giacometti and then enrolled at the Sorbonne to enter the field of the unconscious with the Freudian disciple, Philippe Lacan. Much later, she would return to her native city where she still practices as a psychoanalyst.

"Neapolitans are deeply superstitious," she confesses. "They don't greet psychology with the open mind of Parisians."

Bound by taboo, mental problems in her city often carry public stigma. Personal torments remain tightly bound in private inner family walls. Her patient visits must be shrouded in secrecy, unlike in Manhattan, where having an analyst is a badge of honor.

* * *

Next morning, Assunta in her sky-blue apron brings a pitcher of warm milk to the breakfast table to add to our brewed espresso, steaming in porcelain cups. Light illuminates the dining room that faces the rippling great bay, where a shrill sun reflects its silver sheen on the jade-blue expanse. Vesuvius's twin craters lift high above delicate nesting clouds. The grand marine arc stretches from our host's terraces to the far cliffs of Sorrento. Marmalade from Ravello lemons covers our toasted bread. Idanna leafs through the heavy volume *La Cucina Napoletana*.

"It's by Jeanne Caròla, Paola's mother. Listen to her words," she says. "'This book is dedicated to the grandchildren of all the Neapolitans scattered around the world. How can I, neither a scholar nor a writer of literature, express my love for this most unfortunate city, so rich in its past and poor in its present?'"

Standing at the door in her burgundy silk dressing gown, Paola savors every word. Then she takes her place at table and recalls how the Caròla family meals often ended with her father's biting remark that his own mother's cooking was the best in the world.

"Hearing those unpleasant words, my mother always fell silent. But slowly, with persistence, she managed to surpass her mother-in-law's reputation. She abandoned the typical Neapolitan recipes and ventured into a level beyond her rival's reach—the territory of the legendary *monsù*."

These alchemist-chefs exist now only in legend, but once they reigned in the aristocratic kitchens of Naples. After the French Revolution, they fled Paris and came south to offer their services to the nobility. Over time *monsieur* morphed into *monsù*.

Paola describes with great relish the world of her mother's kitchen, where preparations took entire days. *Pasta frolla* filled with fresh shrimp

and mussels; miniature boats of buttered *pain carré* with parsley; fried sliced *zucchini a' scapece* dressed with fresh mint; chestnut and cacao balls coated with caramel, candied orange peels, chocolate truffles . . . Each meal became a cornucopia of delicacies, breaking new ground. "And, finally, in triumph, my mother published her book," she says. "Now it's known as the 'Bible of Neapolitan cooking.'"

As Paola pulls away from the table, she announces that it is her wish to escort us into the quarter of ancient Neapolis.

"To . . . day, I will show you *una mer-a-viglia,*" she purrs, tasting each syllable. "A true wonder. There is the Cara-vag-gio, you must see . . ."

"How lovely," Idanna says.

"But remember," Paola says sternly, "leave your valuables behind. Carry nothing." She echoes Puccio's warning.

We dutifully prepare. I assist Paola in the ritual of closing up the house. I bolt each shutter while she carefully shuts every window. Darkness slowly swallows room after room. When the last window is closed, the illuminated outside world retreats completely. Then she sets the alarm.

We follow her through the shaded garden of palms, cactus, pomegranate bushes, and then climb the stairs that lead to the gate and the road of Posillipo. Harsh sunlight blinds us with its white uniform haze. We leave behind one face of Naples and descend into another.

A half hour later, our taxi driver pulls up in front of the imposing Duomo of San Gennaro and we step out. Idanna whispers in my ear, "Inside there, the relics of the city's patron saint are stored. When his blood miraculously becomes liquid twice a year, Naples goes into a complete frenzy."

Over two millennia ago, Greek colonizers laid down the grid pattern of the city's "historic center." Spaccanapoli, *spacca* meaning "cut." And slicing through the heart of ancient Napoli is Via dei Tribunali—the Street of the Tribunals. First laid down by Hellenic founders, this ancient artery cleaves the old city in two. It still follows its original trajectory, in spite of layers of urban chaos where buildings have risen and crumbled and risen again for centuries. Here dwells a sea of humanity pressed together like sardines. Underground extends a vast network of

caves and tunnels carved out since the Roman epoch from the soft vol-
canic *tufo* that was quarried to build the city's structures above. Beneath
the old city rests a negative space mirroring what stands above.

The writer Curzio Malaparte describes this living archeological site
in his book *The Skin*:

> *Naples is the most mysterious city in the world. It is the only city of the
> ancient world that has not perished like Ilium, Nineveh, and Baby-
> lon. Naples is a Pompeii that was never buried. It is not a city: it is
> a world—the ancient pre-Christian world—that has survived intact
> on the surface of the modern world.*

Navigating through the dense crowd, we enter a jumbled forest of once-
proud palaces and timeworn tenements. I marvel at the anarchy. Along
a stretch of broken pavement and down a side street, we step into a tiny
piazza and pull up before a forlorn church façade. At the entrance, a
gap-toothed woman sits quite comfortably behind her makeshift table,
hawking cigarettes. A speeding Vespa with a sixth sense maneuvers in
around me in a split second, scraping at my ankles. I hurriedly follow
the ladies inside. As the wooden door closes behind us, the bedlam
subsides. A quiet hush.

Before us, a tiny wooden sign reads *Le sette opere della misericordia—
the Seven Acts of Mercy.* My gaze slowly rises to the grand painting above
the dimly lit altar. I step closer, drawn in by the eerie *chiaroscuro*, with
figures so lifelike. I've never seen any painting like this. Startling. Mag-
netic. Strange. In the painting, an old man suckles a woman's breast
as she turns her face nervously toward a grim alley. What's happening
here? Costumed men grapple in the darkness. Who are they? Someone
holds a torch, two dirty feet stick out from under a sheet, a sword blade
shines, a half-naked body kicks up some dust. From above, a mother
and child peer at the chaos below. Two angels fall to earth, grasping
each other. Their wings bat against the walls. Yet they look more like
Neapolitan street kids. I don't understand.

I turn to Paola, but she offers no explanation. Instead, she sits con-
tent on a scarlet cushioned chair, delighted that she's offered us this

unfathomable painting. After lingering for a while, Idanna turns to leave. I do the same. Paola rises too.

Suddenly, a voice behind us echoes off the walls.

"*Ma che fate*, what are you doing?!"

A thin man with silver hair and blazing eyes moves toward us through shadow and light. "*Non andate via,* don't leave," he cries out.

"Listen . . . !"

Chapter 2

DUEL IN ROME: ESCAPE TO NAPLES

As they waited for the attack that they knew would be the last, one of them said he had heard the Persians were so numerous that when they shot their arrows, they hid the sky. "Good," said another. "Then we will fight in the shade."
—*Herodotus (440 BC),* The Histories

Staring back through the blurred lens of time, a lonely figure paces toward us this warm May evening on the banks of the Tiber. Over his shoulders hangs a fashionable black cape. At his hip glistens a razor-sharp rapier. Like most artists in Rome these days, he carries a weapon. It's only natural. Nights in the holy city are fearsome. Brawls and swordplay erupt as if by clockwork. Painters from rival factions don't argue about their styles in cafés; they cross swords in bloody duels and pitched battles. As the figure approaches, his eyes scan left and right.

Look closely at his trimmed beard, piercing eyes, and unkempt hair. They call him Michelangelo Merisi. Later generations will remember him only as "Caravaggio"—a small town forty miles east of Milan. Like the maestro from "Vinci," he will be forever be known by the name of his ancestral town.

At the dawn of the year 1600, Rome stands triumphant as the "New Jerusalem," having faced down Luther's revolt that now divides Christian Europe. The building spree of Pope Sixtus has reshaped the eternal city into a theatrical showcase. New squares, fountains, boulevards, and churches all conspire to dazzle all visitors. Colossal domes float high above grand

avenues. Egyptian obelisks soar over spacious piazzas. St. Peter's Basilica radiates with regal flamboyance.

Arriving pilgrims stand, mouths agape, before these majestic stage sets of the renewed faith. Cardinals rule as princes from lavish palaces. The pope reigns as the supreme monarch.

Yet, as the sun sets over the seven hills, Rome slips on her nocturnal mask. Night crawlers, swindlers, and prostitutes spill out of the taverns each evening. Hired killers prowl the alleys in armed gangs. The pillar of Christendom has also become a thieves' paradise.

The rich scarlet, emerald, and cobalt hues of the Renaissance are now distant memories. The ruling Spaniards set the latest fashion trends. Their favorite color captures the mood: charcoal black. Rome basks in splendor, but a dark veil has fallen across the Italian peninsula. Waves of foreign invasions have unleashed a plague of violence and lawlessness. Once proud city-states suffer under the sharp heel of Spanish overlords empowered by New World booty. The Republic of Florence lies crushed under the Medici dictatorship of Cosimo I and his wife Eleanor from Toledo. Goliath has defeated Michelangelo's David. Machiavelli's warnings about tyranny prove prophetic. His writings define this age.

A conservative backlash is afoot. The famed Council of Trent, encamped in the high Alpine city for three decades, has hammered out new doctrines for all modes of belief, ritual, daily life, and even art. The resurgent Church, infused with new blood and energy, has declared a Counter-Reformation. Assaults on Protestant heretics sweep the continent.

Grandeur and confidence underscore the revived faith. On church walls, Baroque artworks reflect the intensity of passions, indoctrinating the illiterate who flock to pray. Painters' dark canvases mirror the repression in the air. Martyrs are in vogue. Saint Sebastian, a pincushion of arrows, looks up to storm clouds in ecstasy. Madonna and child are no longer encircled by the fertility of nature in springtime. Night has fallen and the aging mother stands alone, mourning her dying son.

The dazzling Mediterranean light that daily spills across these lands is nowhere to be seen in art. The rays of the sun have been snuffed out. Blackened hues shade artists' imagination. For Caravaggio and his followers, it will always be midnight.

The Neapolitan poet Tomaso Campanella sums up his epoch:

> The century is dark, it cannot see the sky.
> The stars are cloaked by clouds.
> There is no glow, the sun has disappeared in darkness.
> And the moon is blood.

Prestige has closely bonded with art in this autocratic age. Each feeds off the other. Appetites for fine paintings grow with each passing day. The Medici in Florence, the Gonzagas in Mantova, and the Borghese in Rome all employ spies and agents in their hunt for works by masters. And the Church is the greatest patron of all. In this cutthroat competition, one artist is sought out above all others: the lone painter who strides along the banks of the Tiber.

* * *

The swelling river rushes past. Twilight has faded. Caravaggio nervously touches his rapier. Under his dark mane of shaggy hair, his eyes glisten. Tonight he does not hide his scabbard under his cloak, but keeps it in open view. All his senses are alert. Three comrades follow closely behind. One sudden glance. A curled eyebrow. Stinging insults. A flick of the wrist. A blade's trajectory. Tonight, May 29, 1606, a score will be settled and his destiny will change forever.

The new game of pallacorda *has swept Rome. This forerunner of tennis is all the rage. Sportsmen use their bare hands as rackets and play inside walled galleries. Near one such court by the Florentine embassy, the artist and his friends will cross paths with a petty gangster and neighborhood enforcer, Ranuccio Tomassoni, and his swaggering gang of thugs.*

What triggers the brawl? What ignites their tempers? We don't know. Is it an unpaid debt? Or a dispute over an umpire's call? Or is it bitter factional politics? Conservative Spanish supporters often clash with the liberal French who have lost the papacy. Tomassoni runs with the Spaniards. Caravaggio's lot is cast with the French. Or could it be their ongoing feud over Fillide Melandroni? After all, the striking courtesan has served as Caravaggio's model for his paintings Saint Catherine *and* Portrait of a Courtesan.

Rumors have it that Tomassoni has abused her. Does Caravaggio want to avenge her honor? Whatever the reasons, it will remain a mystery.

On this fateful Sunday evening, the duelists pace up and down, taunting each other. Four armed men stand on each side, ready for battle. Adrenaline rushes. Curses fly. Hands reach for weapons. Blades slide swiftly out of scabbards, singing in the night air. The fighting begins. Steel clashes in a mêlée of slashing and thrusting.

At this point, accounts vary. Some claim that the two enemies fight alone. Others describe a free-for-all where the artist rushes to a comrade's defense. In the chaos, Tomassoni trips and falls to the ground. Caravaggio lowers his rapier to the ruffian's thigh. The blade cuts. Blood gushes from a severed vein. Tomassoni's brother quickly lunges and strikes the painter on the head. Dazed and bleeding, Caravaggio reels back.

At that moment, shouts echo down nearby alleys. The sbirri, *the dreaded Papal police, are closing in. The fighters break and run. Each knows that he'll pay dearly if caught—sword fighting in the holy city is a capital offense. The Tomassoni gang hurriedly carries their bleeding brother home to Piazza San Lorenzo.*

Suffering from his nasty head wound, the painter staggers away in the night with his comrades. One of them, known as the "captain from Bologna," cannot follow. He has deep cuts at a knee, heel, and arm. Later, a surgeon was to note, "I removed seven pieces of bone. He will never walk again."

Ranuccio Tomassoni dies before sunrise.

The next morning, allies clandestinely spirit Caravaggio out of the city to the wine-rich volcanic hills southeast of Rome. There he will heal in secret on the feudal estate of the powerful, princely Colonna family. Incommunicado. Under wraps.

In Rome, the police search high and low for the killer. Rumors fly. Some say that Caravaggio only meant to wound. Others insist he wanted to emasculate his rival. The painter is nowhere to be found. Many believe he has fled north to Florence or back to his hometown. Guards at the northern city gates check for his passage.

In no time at all, the duel becomes the talk of the town. Reports travel by couriers on horseback to distant capitals, where patrons have their eyes on the young celebrity's paintings.

The Dorias of Genoa, the Gonzagas of Mantua, the Medici of Florence, all read the bloody details. One agent of the Duke of Mantua excitedly refers to the fugitive as "the most famous modern artist."

Safely hidden in a Colonna villa, Caravaggio hears the grave news. He now stands charged with murder. His sword and brushes lay close by. As his head wound heals, a dramatic chasm looms before him. Staring into the abyss, he immerses himself in painting Mary Magdalene, whose despair mirrors his own.

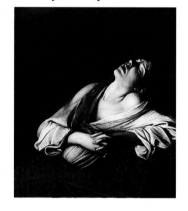

The woman's stark image is otherworldly. Her head is flung back, eyes closed, lips opened in anguish and abandonment. Beloved by Christ. Shunned and cast out by his jealous disciples. She is the heroine denied. Through Mary Magdalene, the painter conveys the loss of his own world, his friends, his Rome. Like her, Caravaggio knows he cannot turn the hour back.

The new Pope, Paul V, has a distinct distaste for swordplay in his turbulent city. Harsh punishments await duelists. Mercy is rarely shown. On Sant'Angelo Bridge, severed heads on public display remind citizens of their Holy Father's iron rule.

As Caravaggio paints in hiding, the verdict is announced: Pena di Morte. *Death sentence. Even for cynical Romans, this ruling seems too heavy-handed. Everyone knows that street brawls carry collective guilt. Full blame rarely rests on one combatant's shoulders. In the past, the Tomassoni brothers have gotten off scot-free for similar offenses, and this homicide was clearly not premeditated. Yet now any bounty hunter can collect the reward by taking the artist's head.*

Caravaggio knows he must move on. But he won't travel north as rumored. He will not seek safe haven in his homeland. Instead, he will do the opposite. In a desperate gamble, he heads farther south toward the border.

Below the Papal State lies il Regno—*curiously named Kingdom of the Two Sicilies. With his rolled-up canvases strapped to his saddle, Caravaggio*

rides across the "no man's land" of lower Lazio, long haunted by bandits and brigands. He eludes all takers. At the frontier, he slips over the border under cover of darkness. By morning, he is riding through the green fields of Campania, passing farmers who raise their heads to stare at the solitary traveler in the blazing June sun.

Days later, he passes under the massive gates of Naples and steps into Europe's second largest city after Paris. Cosmopolitan and grand, this royal capital, a pulsing beehive of humanity, is three times the size of Rome and is ruled by a Spanish viceroy. The boisterous streets run beneath towering buildings that soar high above. Deep in the city's heart lie countless alleys where the sun never shines. Inside the fortified walls lives the densest urban population of the planet. Here Caravaggio walks, a free man.

The dogs of prey have lost his scent. In Naples, he can breathe again.

Here, Caravaggio finds mercy.

* * *

This thrilling, congested capital bubbles with an energy his eyes have not seen before. It is forbidden to build beyond the city walls, so there is only one direction for this metropolis to grow. Vertically. Straight up. Buildings leap four, five, even six stories into the sky, blocking out any trace of sunlight. In this shadow land, Caravaggio meanders in the tallest city on earth.

Shouts echo as flocks of black-robed priests, Spanish soldiers, and prostitutes swarm the crowded streets, passing outstretched hands of mendicants. The piazzas are raucous and bazaar-like, filled with fortune-tellers, jugglers, and minstrels, who flee by evening. Virtually incomprehensible to Caravaggio, the Neapolitan dialect rings out with heavy nasal drawls that elongate words in a rapid cadence. He feels light-headed, in a carnival mood, and studies gestures and movements. This is another country.

Down by the docks, he finds a modern-day Tower of Babel. Foreign-born sailors unload imports from far-flung realms strung along the Mediterranean's Islamic shores. Strange tongues haggle and banter. Turbaned Egyptians from the Nile Delta offer spices that sailed out from Alexandria's Pepper Gate weeks earlier. Doe-eyed Moors from Orhan and Tangier judiciously pay with gold pieces that have crossed the great Sahara desert.

On these heaving wharves, polyglot Greeks translate Turkish and Arabic dialects into Italian for Levantine merchants auctioning off carpets from Istanbul's Grand Bazaar, perfume from Damascus souks, and silks from turquoise-domed Isfahan. Eager Flemish and Bavarian agents bargain on behalf of their clients from Northern European courts. Fortune-seekers from Andalusia stare in wonder at the trade of the Kingdom of the Two Sicilies. This land is so rich that the Spaniards call this jewel of their empire the "Indies of the East."

Meanwhile, day after day, ships sail for Valencia and Seville, loaded with mountains of grain, barrels of olive oil from Apulia, and wine from Campania. Precious little is left behind for the starving poor. Viceroy Alfonso Pimentel d'Herrera, Count of Benavente, has rationed bread and placed a tax on fruit. Legions of famished, ragged "lazzaroni"— Neapolitan clans of beggars and thieves named after Lazarus—swarm the streets. Hunger grips the city that faces its worst famine in forty years. Patrolling Spanish police growl in Castilian or Catalan, trying to keep a lid on popular unrest that may explode at any minute. They are very busy men.

Instinctively, Caravaggio pulls back as a group of armed Spaniards swagger past. Glares of hate follow in their wake. Just a glance of their glinting swords sets the artist's blood racing as he remembers the price on his head. He feels suddenly parched, a feeling of dread. Then he calms down. The Pope's sbirri are a country away.

His ruddy attractiveness—black wavy hair, curling mustache, dark eyes—allows him to blend into the crowds much more easily than the Muslim spice traders or the blond German merchants. He breathes a sigh of relief.

The painter's eagle eyes flash right and left, taking it all in: crying babies in mothers' arms, scrawny men in rags, wealthy patricians festooned in fine lace, young rascals eyeing belt wallets, a rolling sea of humanity that parts only for shining black steeds that rumble past, pulling polished carriages.

Gaggles of shrouded women spill out of churches. Fishmongers bark about their red mullet, slick squid, pink crab. Snarling cats chew on tuna heads tossed underfoot.

He walks through a forest of anarchy.
In the shadows, cripples and beggars huddle together.
A water jug is passed to a thirsty mouth.
Another hand offers a piece of bread.

Part 2

THE SEVEN ACTS OF MERCY

Chapter 3

Dolce Vita and Malavita

Recognize who and what, in the midst of the inferno, are not inferno, then make them endure, give them space.

—*Italo Calvino*, Invisible Cities

"Listen! If you've got time, I will explain the painting," insists the thin man with fiery eyes.

His loud words stop us in our tracks.

He draws nearer, looking at me quizzically.

"You're not Italian?" he asks, "American?"

"Yes," I reply.

"And you, *signora*?"

"From Firenze . . ." answers Idanna.

"Ahhh, I worked in Grosseto many years ago," he says, smiling.

"I am Neapolitan," interrupts Paola abruptly. "These are my friends."

He turns quickly in her direction, welcoming her.

"*Grazie, signora,* for coming here with your guests."

His face holds a battery of emotions, with a pair of bright blue eyes gleaming behind his glasses perched on an aquiline nose. His wiry torso is charged with the tension of a compressed spring and energy to burn.

Standing before the painting, he asks, "Do you know what it means?"

As he begins to describe what we have not seen, I somehow understand him through his thick Neapolitan accent.

"It's from the Gospel of Matthew," he says, "These scenes could be happening just around the corner, in one of these alleys."

The man's cadence is gripping. Our eyes are fixed on the painting. As he speaks, the figures seem to stir, alive. All the noises, smells, and loud intensity of the streets outside now pulsate from the canvas. Strong raking light picks out each character.

"Look on the right side. We should begin there." He points over to a young woman and an old man's head reaching out from prison bars.

"Isn't she beautiful? And what is she up to? You won't believe it. She's breastfeeding her father."

"Breastfeeding? Her own father?!" Idanna gasps.

"Yes, exactly. Look, she's raised her skirt and put it under his chin for comfort. In those days, families had to provide food for relatives in prison. So you see, this scene combines two acts of mercy—feeding the hungry and visiting the prisoners." He pauses in admiration. "Of course, it's also about honoring your parents and the elderly, no matter how and what."

Then he carefully guides us through all the acts, one by one, pointing out that Caravaggio ingeniously managed to place all seven in one narrative. "With so little space, how did he do all this?" he wonders out loud.

Idanna and I exchange glances. The passionate erudition that flows out of the humble man is unnerving. As I listen to his delivery, I realize that this is no textbook rendition. It's coming from a deeper place within him. Like most Neapolitans, he seems to have a natural gift for theatrics and pacing.

When he stands back and takes a breath, I offer him my bottle of water. "*Prego* . . ."

"*Grazie*." He takes a sip. "You see Caravaggio suffered so much in his life. The Vatican wanted his head. A man had been stabbed to death," he stresses in a hushed tone, handing me back the water. "Come nearer, and look down in the lower left corner."

I crane my neck but don't see anything. Idanna stares in concentration at that spot on the canvas.

"The painting shouldn't be seen in artificial light," he says firmly, "but sometimes it helps." He reaches behind the curtain and flicks a switch. The scenes glow brightly in the electric light.

"Under that sword, you see?"

I recognize a small figure crouched in shadow behind the blade, hands folded.

"That's his anguished soul, I'm sure. This entire painting is his cry for forgiveness and compassion in this mad world. But isn't that what we all want?"

Idanna reaches out and touches his arm.

"Excuse me, but what is your name?" she asks suddenly, changing the subject and looking straight into the man's crystalline blue eyes.

"Angelo Esposito," he replies. "I am the guardian here."

Paola, who has been silent, plucks out some money from her purse and gestures for him to take it.

"*Signora*, please!" He steps back, offended.

"For your next coffee . . ."

"No, absolutely not! This is my duty and my love."

She lowers her hand.

He then flips over the lapel of his jacket to show us a silver badge with the words: *Comune di Napoli*.

"I work for the City," he announces proudly.

"And how long have you been here?" probes Idanna.

"Almost five years."

"And before?"

"I worked fifteen years in the Sanitation Department," he answers candidly.

"Really?" Idanna exclaims. "Not . . ."

"Yes, in the city sewage system. But then they moved me over here to culture."

He smiles at our startled expressions. From the cupola, a stream of sunlight flashes on his sharp nose and firm chin.

We thank him warmly and shake hands. His eyes sparkle as he walks over to switch off the electric light.

Before pushing the door, I turn back to take one last look. The thin guardian stands dwarfed underneath the painting.

Outside, an old woman offers us cigarettes and a big toothless smile. Motorcycles roar past.

Idanna asks Paola, ". . . but how can he know so much about Caravaggio?"

"I have no idea . . . this is Naples," she answers dismissively.

We cross over Piazza San Domenico Maggiore and Idanna disappears inside a bookshop. I wait outside with Paola, who seems eager to return to her home on the cliff. Soon, Idanna surfaces with a book in hand.

That evening, she sits absorbed and lost in the pages of her new acquisition. Paola has long since gone to bed. After some time, she looks up as if surprised to find herself still here in the living room. I close my dog-eared copy of Robert Byron's *Road to Oxiana*.

"Since my childhood days in Florence," she tells me, "I've seen many spells cast on travelers, but today . . ."

"Yes," I agree, "He is possessed."

"Tomorrow, I want to go back there . . ." She pauses. "To the church."

* * *

Naples is a town of ancient things projected into the future with an innate, almost unconscious, comprehension of eternal values.

 —*Roberto Rossellini*

Harsh dawn light batters the wall with white streaks. Careening seagulls cry as Idanna peers out into the glare. Curtains of Indian muslin wrap around her like windblown sails. She gazes out at her grandmother's bay. But, from her eyes, I know she is still thinking about our encounter with the guardian and the painting of "mercies."

From the cliffs of Posillipo, we head past *nonna's* Villa Pavoncelli down to Mergellina and then along the promenade all the way to the medieval *Castel dell'Ovo,* or Egg Castle, that floats offshore—still oozing its curious history of subterranean intrigue and murder.

In Santa Lucia, facing the sea, we stop for a coffee. At the next table, a couple of men in suits pompously chat. They look like political operators and fixers trading their harvest of jokes, puns, and double entendres. Their obedient drivers stand by government-issued "blue cars" parked at the curb. In any just society, such shady rascals would be locked up. Yet here in Italy, they enter politics. The party hacks climb up the ladders of their parties and, over time, thanks to an endless stream of brown

envelopes passed under tables for government contracts, they become rich. In the end, the system is rigged. Everyone is bound to them for favors at a price—a job, a building permit, a license, a contract, and more.

Idanna looks at them sternly. "Just imagine, Italy has only been united for about a hundred and fifty years, when the North conquered Southern Italy. Since then, two secret organizations have kept the country in suspended animation—the Mafia, and the Freemasons. After the war, some would add a third—the Vatican's Opus Dei."

"And these politicians?"

"They just do their bidding. Idiotic governance, hand in hand with the Mafia, holds everything hostage. Corruption, nepotism, and inside deals ruin this beautiful country. Have a look at those faces and you know why Italy will always be in a mess."

I scan their expansive waistlines, Prada glasses, slick hair, Rolex watches, and glistening Gucci shoes. One lifts a morning *prosecco*. Another puffs his cigar.

Even under the bright morning sun, this improvised entourage clouds over any *Dolce Vita* fantasies with *chiaroscuro*. These toxic characters—straight out of central casting—seem all too happy to illustrate modern Italy's curse for us.

From Santa Lucia, we trudge up to Piazza del Plebiscito and the Royal Palace before descending into Piazza del Gesù Nuovo, which faces the heart of the old city. Slowly we reenter Spaccanapoli's jumbled forest of architecture from all ages and seasons. On dark and pungent San Biagio dei Librai Street, I hear swarms of rapid-fire voices, laden with nasal drawls so similar to Alexandrian or Beiruti cadences in worlds east of Naples. I had spent a decade in those Middle Eastern lands of broken hopes and dreams.

A familiar warmth sweeps over me as we walk, wedged between battered relics of palaces and historic buildings, long since decayed and shedding their cracked and wrinkled skin. Ambling along Via dei Tribunali, Vespas weave maniacally in and out between cars. Anxious drivers honk their horns, asserting their manhood. A young kid puffs on contraband Marlboros and casually tosses firecrackers into the traffic. Idanna grabs my arm.

Finally we find our way back, retracing our steps into the little piazza. Standing before the weather-worn façade of the church, I spot the woman hawking her cigarettes. She recognizes us and grins her gap-toothed smile back in our direction. A speeding motorbike deftly skirts round Idanna. She holds her purse firmly. We pass through an iron gate and push open the wooden door. At times, churches in Naples are not so much places of spiritual comfort as places of refuge from the blaring noise of the narrow streets.

A cool draft of wind blows over us.

The church is empty. The door closes behind. All the chaos of the street outside subsides. A quiet hush. Peace. The grand painting looms above the dimly lit altar. Drawn by its mysterious beauty, we step closer. In silence, I count the characters: sixteen. Who are they?

Then I hear his voice.

"I'm happy to see you again," Angelo says with an air of surprise. His eyes glow as he moves toward us across the black and white marble floor.

"I found this book by Mina Gregori." Idanna pulls it out from her bag. "She's a friend of my family in Florence . . ."

"*Che bello!*" He holds it, and his smile lights up when he sees the title, *The Age of Caravaggio*. "You know, you can get hooked on him, if you're not careful," he jokes.

"I can imagine," she agrees.

He thumbs the pages of the book. "No painter can be compared to him. Not even Leonardo. At least this is what I think. But if you want to go deeper, you have to look for the symbols," he stresses. "You have to use biblical and classical eyes."

Idanna is impressed by his erudition. "Excuse me, Angelo, that woman up there. Who is she?" She points to the striking female in the painting.

"Ever heard the story of Pero and old Cimon?"

"No." She shakes her head.

"In ancient Rome, there was a young woman called Pero. One day, her father was arrested for some reason I don't remember. Well, she goes to his rescue and keeps him alive."

"Look closely . . . she's afraid that somebody may see her. But her *papà* is so famished that he has even spilled two drops of milk."

Sure enough, I see the drops on his beard.

"What she fears most are the prison guards." Angelo raises his hand. "But when the guards come out, they will be so moved by her daring that they'll open the prison doors. Her father will walk out a free man!"

The guardian waves his hands in triumph. Idanna stares at Pero's face, glistening with light.

"Caravaggio always shocks us," Angelo emphasizes, "pushing us beyond taboos."

He is so right. Caravaggio takes stories that are so remote and gives them a familiar immediacy. What is so far in time seems to happen next door.

"And who's the pudgy man?" I ask, pointing up. "The one in the corner."

"An innkeeper."

"He looks German, a heavy beer drinker."

"Good guess. In those days, the whole world came to Naples. And everyone passed through the Cerriglio, Caravaggio's favorite hangout."

"Does it still exist?"

"Of course, but now mostly students from the Orientale go there. But look, he's inviting two pilgrims into his tavern, giving them shelter. One has a red beard and a walking stick. The other, we can only see his ear and a leg."

I then ask him about the red-bearded pilgrim.

"See the small conch on his hat?" he replies. "That's the clue. It's the symbol of the famous pilgrimage site, Santiago de Compostela, and also of Saint Rocco, the most popular saint of Southern Italy."

"And who's that man with a torch?"

"That's a priest looking down at a corpse. When Caravaggio arrived in Naples, death was everywhere. Those two feet belong to a victim from the famine who is being carried away."

"Burying the dead?" Idanna prompts.

"Yes," he says, nodding." You see, each figure in the painting is separate and yet moves in unison with the others. Caravaggio catches them in action and freezes the moment."

"And the young knight with the shining sword?" I ask.

"He's cutting his cape to give it to the cripple on the ground. He's Saint Martin."

I look intently at the naked man who is pushing his body closer to the passing knight, with the little strength he has.

"Clothing the naked and caring for the sick. Martin's gesture is powerful."

"That's when the weather changes suddenly and it becomes warm," recalls Idanna.

"Yes, on his name day, always in November, the summer of Saint Martin. It usually lasts a week."

"Indian summer," I say.

"Look, he's given up his cloak, so God blesses him with warm weather," says Angelo with a smile.

Two angels fly above the street scenes in wonder. Their wings churn in a whirlpool of feathers, holding up the mother and child.

"And," Angelo puts a question, "where to do you think Caravaggio got the idea of the white flowing fabric wrapped around the angels?" Not waiting for our reply, he grabs my arm.

"Come!" He rushes us outside and, in the midst of traffic, he stops and points at the clotheslines high above our heads.

"See those sheets up there?" The wind lifts the dangling white fabrics just like in the painting. "So you see, Caravaggio didn't have to go too far. He just had to observe life right here in Spaccanapoli."

The sheets sway between the decaying buildings and the brilliant sky. The guardian clearly enjoys seeing us hang on his every word. He moves with agility as he spins around the cigarette seller.

"Giovanna!" He blows her a kiss.

"*Grazie!* Angelo!" she cries as we are swept back into the chapel.

Inside, I ask about one last character. "And who's that fellow drinking?"

The tavern's light spills on his rugged face. The guardian beckons us to move closer.

"Samson. He's quenching his thirst. Water to the thirsty."

"After his famous battle with the Philistines?"

"Exactly, drinking from the jaw of an ass . . . But he's also cleansing his soul from the blood of all the enemies he has killed."

Angelo lowers his voice. "I think it's Caravaggio's self-portrait. I told you how he stabbed a thug who had provoked him in Rome."

"But didn't he also have big problems with the Church?" I prod.

"Of course," Angelo replies. "He couldn't stand their hypocrisy. The Vatican was after him too. In the end, his art isn't about bishops in silk robes giving handouts to the needy. It's about simple people helping one another. He's the artist of the poor. Our artist! There's no one else like him. It's all there! *Cosa volete di più?* What more do you want?"

His voice echoes in the chapel. His eyes, enlarged by his spectacles, are lit with flame.

Chapter 4

SEVEN YOUNG PATRONS

Exile is round in shape, a circle, a ring.
Your feet go in circles, you cross land
And it is not your land . . .

—*Pablo Neruda*, Isla Negra

*H*igh *above the squalid streets, in the so-called* piano nobile, *or the first floor of many Neapolitan palaces, tongues of pampered aristocrats wag about the latest news.*

"He's staying on Via Chiaia . . . in Palazzo Carafa-Colonna."

"Did you hear what happened in Rome?"

"Yes, but he is safe with us. Rome's loss is our gain."

Gossip trades back and forth.

Some have already seen his work in Rome. Those few who know details of his life repeat them to eager ears. Many want to know more about Princess Costanza of the powerful Colonna family, whom everyone refers to as Donna Costanza. Thanks to her, Caravaggio has come, staying as guest of her nephew, Don Luigi Carafa-Colonna.

But what is the connection between the lady and the painter? It goes back to when he was a child, many years ago, in the town of Caravaggio, forty kilometers east of Milan. And what had taken this Roman princess up north to Lombardy?

Her story is a strange one. Costanza arrived in Caravaggio in 1568, three years before the painter's birth, as the twelve-year-old bride of Don

Francesco I Sforza. Her new husband Francesco was the Marquis of Caravaggio and only seventeen. Soon, little Costanza spiraled into deep depression. In her despair, the girl wrote to her father, Prince Marcantonio Colonna—hero of the epic battle of Lepanto off the coast of Greece that ended the threat of the Ottoman fleet in western Mediterranean waters.

Her letter declared that she was ready to commit suicide and lose her soul if she had to stay married to her husband. Prince Colonna loved his daughter dearly and urgently turned to his relative, the wise Carlo Borromeo, Archbishop of Milan. The prince begged him to rescue Costanza, and it was done.

In secret, the young bride entered a convent in Milan, where she found sympathetic care. Her marriage was over.

But to their great surprise, the nuns soon discovered that the girl was pregnant! And everyone then understood. In her innocence, the princess had mistaken the "natural conjugal act" for violent aggression.

Poor dear, she knew nothing about the facts of life, which had to be delicately explained to her. Slowly she came to understand. And finally she agreed to return to the town of Caravaggio and reconcile with young Francesco. Soon after, she gave birth to the first of their six sons.

Although some say the famed painter we call "Caravaggio" was born into a poor family, this is not true. His maternal grandfather, Gian Giacomo Aratori, was the trusted administrator of Don Francesco and Donna Costanza's household and an esteemed member of the town council. When the artist's parents, Fermo Merisi and Lucia Aratori, were married in 1571, the Marquis of Caravaggio was a witness at the wedding and quite likely his young wife, Costanza, stood next to him. Nine months later, on September 29, a baby boy was born: Michelangelo Merisi.

Fermo chose to reside in Milan, where his skills as a master mason found expression. It is there that the painter came into the world. The Marchioness of Caravaggio must have first seen him as a suckling baby.

When the dreaded bubonic plague swept through Milan five years later, Fermo and Lucia fled back to their hometown of Caravaggio seeking safety. However, tragedy struck all the same, taking both Michelangelo's father and grandfather. His mother Lucia was left alone to raise her children.

At the same time, Donna Costanza also became a widow at only twenty-five, with six small boys. Thankfully, Lucia and her sister

Margherita were close to her. In fact, Margherita was the adored wet nurse of Costanza's brood. All the children must have mingled and played together. It is rumored that Donna Costanza herself taught six-year-old Michelangelo the new catechism of Archbishop Carlo Borromeo, her savior in Milan, who had given new voice to the original humane Christian message so long neglected.

Apparently the gifted boy left home for Milan to begin his artistic path in the prestigious workshop of Simone Peterzano, a pupil of Titian. There he apprenticed for four years. After that his trail goes cold. Probably only the Marchioness was able to keep track of him.

When Michelangelo's mother Lucia passed away in 1590, the family property was sold and divided between his siblings. As far as we know, Michelangelo Merisi left Lombardy two years later, never to return. By then he had squandered his inheritance. All that the young Michelangelo carries with him from that moment on is his talent and his special bond with Donna Costanza. She loves him—not for his genius—but as a wayward son.

They say that he first arrived in Rome during the summer, barely twenty, and penniless. Along the Tiber, he struggles to make his mark. From workshop to tavern, from inn to brothel, he haunts the underworld, battling with rivals, rogues, and his own hot temper. In this melee, the young artist competes with his brush and dagger.

His fortunes turn when the eyes of an enlightened patron fall upon his novel work: scenes with gypsies, tricksters, and gamblers—all drawn from Rome's street life. Cardinal Francesco del Monte, a diplomat tied to the Grand Duke of Tuscany, is an influential member of the Vatican. The cardinal purchases two paintings, The Fortune Teller *and* Cardsharps. *Shortly after, he invites Caravaggio into his Palazzo Madama to live and paint.*

Duly impressed, the cardinal personally arranges a major commission for the prominent Corelli Chapel in the Church of San Luigi dei Francesi, behind Piazza Navona. Caravaggio's first public work—a triptych on the life of Saint Matthew—sends tremors across the city. Some artists hail his daring style, calling it a manifesto of "new art." Other rivals heap abuse colored by jealousy.

As accurate as nature, his astonishing realism is heightened by an arresting chiaroscuro. *Stark lighting captures his characters in the most dramatic moment of their lives. Only naked emotions matter.*

The faithful who enter the church of San Luigi are seized by his "shock of the new." They face figures like themselves in sacred scenes, seemingly alive and breathing. Caravaggio vividly shakes each viewer, reminding them of the poverty and humility of the early Christian era, of the time when a humble carpenter's son walked the earth.

On the left wall of the chapel, The Calling of Matthew *takes place in a local tavern. It could be just down the street. Standing at the doorway, a barefoot and robed Christ points at a startled Matthew dressed in the latest finery with a stylish hat, seated with colleagues counting coins.*

"You!" Christ bellows. "Come with me!"

He points to the tax collector and his hand extends hypnotically, like Michelangelo Buonarroti's God reaching out to Adam in the Sistine

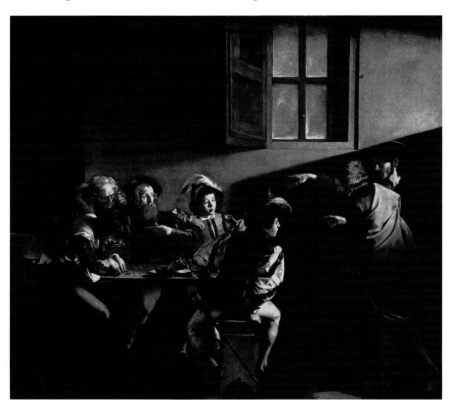

Chapel. *He commands this young man to leave his worldly luxuries of Rome behind.*

"*Who, me?*" *counters the befuddled Matthew. The die is cast. He will follow.*

The second painting, St. Matthew and the Angel, *in the center of the chapel, portrays the balding apostle bending over a simple table, with pen in hand, writing his gospel. One knee rests on a stool. His soiled bare feet are in full view. No trace of worldly comforts. He turns his head to an elegant angel looking over his shoulder, seemingly offering his divine corrections. An editor from above. And Matthew's humbled face is of a writer who knows the edit must stand.*

In the third scene, on the chapel's right wall, the bearded saint meets his frightening end in The Martyrdom of Matthew. *This nightmarish scene appears set in a Roman bathhouse, far from the highlands of Ethiopia where he died. The saint lies on the ground waiting. Terrifying evil gleams in the executioner's eyes.*

Matthew lifts his arm and opens his hand. An angel descends to give him the palm leaf of martyrs. We are witnesses. Our tormented world is the stage.

* * *

> *. . . Light wakes you up and it is not your light.*
> *Night comes down, but your stars are missing.*
> *You discover brothers, but they're not of your blood.*
> —*Pablo Neruda,* Isla Negra

"*He's here!*" *The word passes excitedly. News of Caravaggio's arrival quickly spreads among the Neapolitan nobility. Undaunted by the murder charges, those fascinated by his reputation begin to seek him out.*

One late afternoon, Caravaggio walks up Via Chiaia on his way back to the palace where he resides. Donna Costanza Colonna, who orchestrated his refuge at her family's estate in the Alban Hills, has worked wonders again. Her guiding hand has spirited him into Naples, where he is now guest of her sister's son, Prince Luigi Carafa-Colonna.

The maestro leans back and stares up at the imposing palazzo. Then, he pauses before a cascade of traffic flowing by: jostling carts pulled by donkeys, the cracks of whips, washerwomen carrying bundles on their heads, howling dogs.

He passes inside the palazzo and scales the stairs to the piano nobile *as the Angelus bells toll at dusk. He makes his entry into the grand drawing room and salutes his host Don Luigi. Moments later, seven young gentlemen also arrive and bow to the prince. The young Lombard dressed in black stands behind him. The noblemen scan him with searing eyes. He returns their stare.*

"I present my friends, the founders of the Pious Mount of Mercy," Don Luigi announces proudly. "They work with the poor. I've admired them from the beginning. It's now five years since they started. And my aunt Costanza thinks highly of them. She urged me to bring you all together."

The president, a short, stout man with a warm smile and lively eyes, introduces himself with a bow: Cesare Sersale. Caravaggio returns his salute. Then, one by one, the other six voices pronounce their names: Astorgio Agnese, Giovan Battista d'Alessandro, Giovanni Gambacorta, Girolamo Lagni, Giovanni Battista Manso, and Vincenzo Giovanni Piscicelli.

Marquis Sersale then addresses Caravaggio. "Our dress should not fool you. Nor our lineage. We have chosen to serve the hungry, the sick, and the dying. Our work is outside these windows, in the streets of our city. And we need your help."

The painter looks intrigued. From their privileged world, these young men have embarked on a mission of compassion. They are living the "church of the poor" embraced by Filippo Neri in Rome and Carlo Borromeo of Milan, both of whom Caravaggio deeply admires. Pio Monte, they insist, is independent from the Vatican. The artist senses they know why he's come to Naples. But they don't ask.

"Please sit here, maestro." Sersale motions to him. "Let me tell you how it all started." Caravaggio obliges and sits down.

"It was the third Friday in the steaming month of August," Sersale begins. "One of those days of dolce far niente, *'doing sweet nothing.' We friends gathered in Posillipo by the sea. As we laid down our picnic, suddenly the sky darkened and strong winds began to blow. In a matter of seconds, a furious tempest raged across the bay. The crashing waves forced*

us to take refuge in a grotto. While the deluge lashed the rocks outside, we huddled together in great fear. When the thunderstorm finally passed, our lives had been spared. It all seemed like a divine sign. I rose and made a proposition. 'Let us bring our food to the hospital where it's so needed.'

"Everyone immediately agreed. We bundled up our feast and climbed up to the road. Then we trekked across town until we reached the Hospital of the Incurables. It's a terrifying place. When the sick enter, they rarely leave alive. For the rest of that day we fed the afflicted and comforted the dying. The experience was so intense and rewarding that we decided to meet again there every Friday.

"Soon we were arranging for funerary rites to bury the dead, a ritual usually reserved for the rich and priveleged. You see, here in Naples, death is a full-time occupation. The famine is taking thousands. Disease and cholera run rampant. Each day, men trawl the streets, clearing the abandoned dead and loading them on carts. Then they're thrown like trash outside the city walls into a common pit.

"None of us are firstborn. We do not stand to inherit and have little or no patrimony. Little is expected of us. So we took turns camouflaging our-selves as beggars and standing at the entrance of the Duomo or outside our family palaces. I was the first, and I concealed my face with a hood over my head. At the end of thirty days, my alms box had thirty-three carlini.

"Rumors began to circulate. Our sisters and mothers recognized us and started to make donations to our cause. Other families followed. Last year, at last, the pope granted us official permission to run Pio Monte inde-pendently from the Vatican."

Sersale rises and walks to the window. Then he turns to make his pitch to Caravaggio. "We are the first brotherhood charity to receive such recogni-tion from the Holy See. The Vatican has always prescribed charitable work only to the clergy. But now the acts of mercy are no longer their monopoly. It's a groundbreaking moment. We have just finished building our church. It has taken four years. Above the altar, it's still barren."

"We've been waiting for a great artist," interrupts Piscicelli excitedly, "who will bring luster to our cause."

"And then, by providence, you arrive!" adds Sersale with pathos, handing an open book to the painter. "These verses, maestro, do you know them?"

Caravaggio looks and recites words he knows by heart.

For I was hungry and you gave me food,
I was thirsty and you gave me drink
I was a stranger and you welcomed me . . .

"We ask you, dear maestro," Gambacorta appeals solemnly, "will you consider bringing to life these words from Matthew for our altarpiece?"

The handsome Manso joins in with sophisticated poise. "Sir, the poet Giovan Battista Marino, whom I count as a friend, is a great admirer of your art. I have seen your work in Rome. You move hearts and bring the Gospels alive. No other painter can better capture the spirit of Pio Monte and the pillars of our calling."

Sersale concludes, "We feel that God has sent you."

Don Luigi interjects, raising his hand. "The offer is 400 ducats. Paid once you have finished."

The amount is staggering! The highest he has ever been offered. After all, one ducat is the monthly salary of a soldier. Caravaggio knows this can save him. He pauses in thought, deeply tempted. They seem unconcerned about his death sentence. Not a question about it, and yet they surely must know about the stabbing in Rome.

He studies these young lads who have stepped forward with this prestigious commission. Few noblemen he has known have ever picked up the mantle of the poor. In their family chapels, they may listen to the Gospel that speaks of equality in God's eyes, yet outside their palaces an immense chasm exists between privilege and suffering. At best, a son or daughter may be strategically placed in the clergy or a convent.

But, as a rule, nobility does not reach out to the poor. Breaking this rule defies tradition. Reaching across the social divide is radical, to say the least. Caravaggio knows that these seven young men are doing precisely that. He senses a common cause with them.

He rises to address the young nobles, and declares his terms. "I accept, but I must ask you for funds in advance. Thirty ducats to start."

All agree and shake his hand, one by one.

"We shall draw up the contract, maestro," Sersale's voice booms.

"Signori," Caravaggio announces, "I shall begin tomorrow . . ."

Chapter 5

HONOR THY FATHER

*As far as we can discern, the sole purpose
of human existence is to kindle a light
in the darkness of mere being.*
 —*Carl Jung*, Memories, Dreams, Reflections

*T*he next morning, Caravaggio's frantic search begins for oils, *pigments, canvas, and brushes. There is no time to lose. He storms out of one shop accusing the owner of pushing second-quality merchandise. At one* bottega, *he runs his fingers over the tightly woven linen while listening to the merchant's dialect as thick as the fabric in his hand. Finally, he negotiates for the large piece of canvas.*

Across the street, he discusses measurements with a carpenter for the wooden strainer that will hold the new canvas—about eighteen palmi *high. A flashing glint of light catches his attention, and soon he is bargaining for a mirror hanging on the wall.*

Over the next day, he directs the carpenter who stretches the canvas onto the frame. Then he finds pigments from a druggist he trusts, who carefully places small amounts of ground colors on the table for his inspection. Caravaggio's fingers sift through each: bone black, red lake, lead-tin yellow, umber, copper resin, lead white, and vermilion. The mercury compound of a red-orange hue had been a favorite of Titian. The powders lie there in a rainbow before him.

The shopkeeper tries to tempt him with lapis lazuli, but the artist shakes his head. In this painting, there will be no virginal blue. Far too costly; it comes from distant Persia. Slipping the pigments into his satchel, he tells the owner that he shall return for more. But with these purchases, he is ready to start.

At the chapel of Pio Monte, he reminds Don Cesare Sersale that from this day forward no one can enter without permission. The Marquis gives his word. Sealed off from the outside world, Caravaggio then grinds some pigment with a mortar and pestle. Arranging the colors on a table, he pours from his bottle of walnut oil. His brush swirls. He adds more oil. Mixing back and forth. From powder, the liquid transforms into a rich, dark brown base.

The tone must capture the gloom that sweeps over the city when the hot southern sun vanishes from the sky and the night shadows fall. He has seen raw umber and carbon black on alley walls.

Staring at the empty canvas, he knows this work will be complex. His commissioners have insisted on the six acts in Matthew 25, but the painter has his own idea. Inspired by their mission of caring for the dying, he will add the act of "burying the dead." Seven acts in all—not six.

He ponders the complicated task ahead. Until now, he has always portrayed single scenes in his paintings. But this time, the bar has been raised. All the acts must come alive in one composition, fluid and integrated.

For the first time, he will paint a cityscape, but not an architectural skyline. To capture the anarchy of Naples, he will create a grand sweep of actions with no central pull and no single focus, each scene independent yet interconnected. He will seize all that breathes in the streets, and he will cast it alive onto his canvas.

He will reenact the shocking tumult that confronts each new arrival to this metropolis. In his eye, Naples is a place with no center, a place where words fail. Brimming with life and death. In this city of cities, he will create a universal human-scape of our world.

* * *

Outside the Pio Monte, Caravaggio scans the crowd on Via dei Tribunali. The swell of humanity flows like a river. His eyes fall on a young woman, and he reaches out with his hand to stop her. Upset, she tries to pull away. Fury flashes in her eyes. He tells her he's an artist and asks if she will pose for him. She hears his strange accent.

"Of course, you'll be paid," he assures her.

She looks nervously over her shoulder to see if anyone is watching. He excitedly tells her about his new work. Yes, she knows Matthew's acts of mercy. One scene, he insists, requires her presence. She will be the heroine,

Pero, who saves her famished father in prison. Her eyes grow larger as the painter speaks. The old man can only be kept alive if she brings him food. Pero, who has just given birth, offers him all she has: her own milk.

The young woman stops resisting. Hunger she knows only too well.

"What would you do," the painter challenges, "if your father was starving? Would you help him to stay alive?" His passionate voice holds her attention. The painter lets her arms free. She is silent for a moment, then shyly nods. Now she understands what the stranger wants. And his offer will put food on her family's table for a week.

"Play Pero for me, please," he pleads.

She agrees.

Caravaggio smiles. She's exactly what he needs: a fresh beauty from the popolo—not a mythic Venus playing with cherubs.

Throwing back his cape, he ushers her inside the Pio Monte chapel.

"I will paint you the way you are," he explains. "Stand over there, please." The girl obeys. An oil lamp casts its light on her flowing yellow ocher dress. Carefully, he lifts up a mirror and turns it around until a bold glow reflects on her face and breast. He calls on his apprentice to hold the mirror.

As always, he does not make any detailed preliminary drawing. He mixes walnut oil with pigment and then begins to paint directly on the canvas, already coated with dark red-brown ground. "Turn your head this way." He directs the girl. "You are Pero."

She smiles.

The maestro works quickly and uses his brush handle to make incisions to mark Pero's posture in the still damp undercoat.

After the first sitting, the model feels more at ease before the artist. Then, one afternoon, he asks her to loosen her blouse. She knew this moment would come. She complies and bares her breast. Then he turns toward an old man with long hair and a white beard who has been sitting to the side, waiting to be called.

"It's now your turn," the maestro tells him. With fatigue, still holding his glass of wine, the old man rises. Caravaggio takes away his glass and leads him near the girl.

"Please sit and lean over. As if you're in a prison, putting your head through the bars." Pero's father Cimon follows the order. He sits down and raises his chin toward his daughter. The young woman looks away, embarrassed, while lifting up her skirt to place it under his chin.

"Yes, just perfect!"

But suddenly she hears heavy footsteps, and panics. Who's there? A figure barges in from the shadowed entrance. His voice calls out. The painter doesn't seem to hear. He furiously captures her startled eyes, her open mouth.

Through her eyes, he knows, viewers will enter the painting. The glow on her breast will seize their attention. They will feel her risk and uncertain fate. Meanwhile, her father will continue to suckle her milk, oblivious to swordsmen, torches, beggars, travelers, and the nameless corpse amid the swarming spectacle.

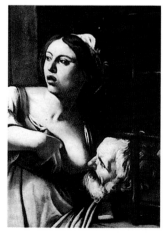

Chapter 6

Upstairs, Downstairs: From Sky to Sea

. . . every painting was like a cell in that great conceptual prison that is Naples, with its past, its faded beauties, its songs. Beyond those scenic views, the myth, and beauty was that open space where I longed to land.
—*Raffaele La Capria*, Capri and No Longer Capri

Scratch the surface in Naples and you'll find an eastern link. The city does not face north to Europe, but to the Orient. She is bound by living memory to her sister ports across the *Mare Nostrum*—Istanbul, Athens, Beirut, Acre, Haifa. Even the lemons of Sorrento recall the long caravan of Jews from Babylon who first carried the noble fruit west. The Neapolitan writer, Raffaele La Capria, calls this bittersweet collective memory *"Mediterranea."*

Under a cloudless sky, we find ourselves in the city's ancient heart on a square named after the great Nile. Two thousand years ago, a colony of Egyptian merchants and sailors from Alexandria settled in this quarter during the reign of Nero. These early immigrants left behind a white marble statue representing the god of the Nile, reclining on a sphinx and breastfeeding a child next to a cornucopia of nature's bounty.

Unearthed in the twelfth century, it soon was known as the *Cuòrpo' e Napule*—the Body of Naples. The child was viewed as symbolizing hungry Neapolitans feeding from the breast of Parthenope, the nymph

who founded the city. Four hundred years later, the head of an aged, bearded man was added to the statue. It continues to be an object of popular "worship." Even the famous eighteenth-century magician, Cagliostro, made a pilgrimage to it. Today, lottery tickets can be found wedged in between the paws of the sphinx.

Quite appropriately, just around the corner, on Piazza San Domenico Maggiore, stands the imposing palace of the famed University Orientale, founded in 1725, the first European linguistic school of Chinese and Asian languages and cultures of the East. Here is where Professore Rossi and his colleagues in Persian Studies are based, along with the priceless library on the Ancient Mediterranean.

Wandering up Via San Gregorio Armeno, Idanna and I pause to listen to vendors hawking their nativity scenes. Since St. Francis invented the crèche in the thirteenth century, artisans here have jealously appropriated it as a Neapolitan specialty. In bazaar-like fashion, thousands of sculpted figurines of the holy family are on display along with adoring mages, loyal donkeys and oxen, flocks of sheep, hosts of winged angels, and mystified shepherds. In Italy, the *presepio,* the nativity, represents the metaphor of Christmas, not a sawed-off pine tree. On the special day, the little god child makes his triumphal appearance in a humble crib, encircled by the waiting entourage in full adoration.

Plucked fruits of the sea are on full view as we pass under the archway on Via dei Tribunali. Early morning's catch on ice: glistening squid and red snapper, ebony clusters of mussels, and swordfish lances. On cue, two women pounce like seagulls snagging their fresh pink shrimp. Fishmongers bark with heavyweight lungs, offering featherweight prices.

A young lady gestures us toward a sign that reads *Napoli Sotterranea*—Subterranean Naples. Beneath the skin of the city lies a network of ancient arteries: Greek cisterns, Roman aqueducts, sewer lines, escape routes, and tunnels linking convents to monasteries.

We continue on and finally end in front of the Pio Monte della Misericordia Church, where I spot old Giovanna peddling her smuggled tobacco.

A month has passed since we've seen Angelo. A smile bursts across his face. His aquamarine eyes light up behind his glasses.

"*Eccoli*, there you are! You're back!" he says.

Entering the church, a deep chill radiates from the marble floor and the walls. Idanna tightens her scarf as he banters back and forth with the usual niceties.

"We can't stay away!" she jokes.

Then, as he grabs a chair for her, she asks the question that's been nagging her for a while.

"Angelo, how did you end up here in this particular church?"

"*Il mio destino . . .*" he answers. "It's my destiny."

"But," insists Idanna, "how did you get from the sewers to *this* Caravaggio?"

He slowly begins to narrate his accidental journey.

"In the early 1990s," he recounts, "Naples was a dying city. Spaccanapoli was a no-go zone for tourists. Most churches were locked up. Then, in a surprise election, a new mayor called Bassolino took back the streets from the Camorra. He called it *Napoli: Porte Aperte*, Naples: Open Doors, after Rossellini's film *Roma Città Aperta*. So he shook the city by the neck, and he woke us up!

"Well, all of a sudden, ancient doors swung open. Historic sites were cleaned up. Churches, like this one, were dusted off. But Bassolino had one big problem. Who was he going to put as guards? Of course, he couldn't hire new people on the payroll. So he came up with something better. He dipped his hand into the garbage and sewage departments for his guards. Probably he also thought we could use a little culture. And in a way he was right. Among hundreds of fellas, I got lucky. So, my dear, that's how I came here."

"And what did you feel at the beginning?" Idanna asks.

"I'll be frank," he confesses, "I really didn't care where I was. None of us did. It was just a job. I didn't give a damn about what was on the walls. Culture is a luxury for the poor. I spent all my time playing cards with my colleagues and chatting, sneaking out for coffee. We were just killing time between one occasional visitor and the other. The authorities tried to make us learn what to say . . . and I just repeated it word

for word, without any idea of what I was saying." He waves his hands with nonchalance.

"But when did it change?"

"After about a year, something began to sink in. I started to like the place. And one day, I looked up. It happened over there!" He points to the front pew where he sat that fateful morning. He had opened the church and quietly waited there for the first visitors to walk in. But then something grabbed him. He felt his gaze being raised up to the altarpiece.

"And I saw the painting as if for the first time!" he says excitedly. "There, on the canvas, I recognized my brothers and sisters! It all happened so suddenly. I couldn't believe it. And soon I found myself searching everywhere for clues about his life. I taught myself how to read again. Now Caravaggio is flowing in my veins!" He raises his arms.

"Incredible!" Idanna exclaims.

"I now see myself in him—impulsive, hot-tempered, and certainly angry with the Church. Like him, I've also had my share of trouble, you know." He lowers his eyes, remembering darker times. Instead of going further into his past, he then flashes forward.

"Now, all I want to do is introduce visitors to the painting. It tells you all you need to know about how to live together. In this crazy violent world, we've got no choice. We must give a hand to one another. If we don't do that, we're dead."

He takes a deep breath.

"Take my friend Giannino at the bar," the guardian continues. "He could be the same tavern keeper you see in the painting. And what about that tall mason making repairs in the courtyard of Pio Monte, isn't he the spitting image of the tall priest up there? All those holy scenes so far from our world, well, with Caravaggio they are taking place now! He holds up a mirror and tells us what it is to be human. With all our imperfections, this is who we are. It's all here!"

* * *

The guardian is right. The maestro openly abandons all the rules of Renaissance painters before him. He turns his back on Raphael's elegant Madonnas and Michelangelo's heroically muscled figures. He rejects the time-honored belief that only handsome, noble saints, all bathed in uniform light, can be painted in sacred scenes. He holds up Nature, just as we see it. Authentic. Not a dreamscape. He thrusts the real world before our eyes.

He grabs the old Christian myths by the collar and shakes off the cobwebs. His paintbrush gives flesh and blood to a dusty past. His apostles wear tattered cloaks and walk on scarred feet. He lifts them out of the alleys. Drags them off work sites. Pulls them up basement steps. Lures them out of taverns.

Caravaggio pushes all these "untouchables" into public view. His Christianity turns hierarchy on its head. It is a faith welcoming all. He doesn't challenge the caste system—he shatters it. His truth ignores earthly divisions of wealth, power, or birth. Just as Gandhi would embrace untouchables as *harijan*, "children of God," and Count Tolstoy would embrace his serfs, Caravaggio does the same in Naples.

By showing this truth, he creates a place where all of humanity stands together. All equal. All sacred.

He elevates us from the provincial to the universal.

From the present to the mythic.

Chapter 7

THE WORLD ACCORDING TO ESPOSITO

It's not important to come out on top, what matters is to be the one who comes out alive.

—*Bertolt Brecht*, Jungle of Cities

It's one o'clock. Closing time. Idanna and I step outside as Angelo locks the iron gate firmly with his huge key. We follow him over to the bar at the corner. He enters and shouts out to his friend, "Giannino, *tre caffè!*"

Served in a flash, we take our cups to a table. Idanna, in her coaxing way, begins to pry into Angelo's past. It's warm inside and he begins to open up.

"So you really want to know my whole story?" He sips his hot coffee. "*Va bene . . .*"

I get up to pay, but he prevents me. "This is my place, *faccio io*, it's on me."

I sit down, knowing I must not insist.

"Listen," he recounts. "I was born in Napoli in 1954 on the fifteenth of January in a two-room basement on the Alley of the Sun, just around the corner from the church. Who knows? Perhaps I was meant from day one to be the guardian of Caravaggio's painting. As far as I can remember, my father was always out of work. My mother would wrap me in a blanket and go begging from bus to bus. She joked that

she could make more money with me because I was such a scrawny, thin baby. The passengers never said 'Oh what a lovely child!'

"Yeah, I must have given people a fright. I was only five months when I fell very sick, and my parents were forced to bring me to the hospital. I don't know how long I stayed there, but I was saved. My *papà* couldn't stop thanking the doctor. 'Don't thank me for God's sakes,' he snapped back. 'I've got nothing to do with it! He just doesn't want to die!'"

He chuckles and calls out to Giannino for some wine. His laughter is contagious, and clients at the bar grin along with us.

"By staying pregnant, my mother stayed out of jail. Even now, in Naples, the police won't lock up a pregnant woman. Quite civilized, no? Poor mamma, she had such a hard life. Out of eighteen children, only nine lived. She didn't have time to look after us. We played in the neighborhood streets. My nickname was 'Garibaldi.' The shopkeepers would pass the word: 'Watch out, here comes Garibaldi!' It was great fun! We were reckless and sneaked into shops to steal. Only when our pockets were full would we go back home.

"All of us had nicknames: Bashful, Sleepy, Red Hat, Spider, Raven. And we all went to the same elementary school, Ettore Carafa, that is still there today. But my father saw I was heading down the wrong road, so he shut me up with my younger brother Salvatore in a reformatory. I was ten years old.

"I tried not to get depressed there. I played football and my team always won. I can't tell you how many goals I kicked in. Our goalie was Giuliano Sarti. I was center forward and our two wings were Mimmo Scarpato and Franco Salle. We were the fastest and the best.

"I wasn't a bad student. My average was good, about seven out of ten. But in all my eight years there, I seldom saw my parents. *Papà* hardly came, my mother about twice a year."

He leans back in his chair, taking another sip of his wine.

"We were only allowed to go home for Christmas and Easter. I remember once playing with my brother's colored marbles, and I hid two in my mouth. My brother saw me and squealed to *papà,* who lost his temper and grabbed an empty two-liter wine flask and smashed it over my head."

"My God, and then?" Idanna cries out.

"Well, the flask broke into a thousand pieces and *papà* was left holding the bottle neck. Then he grabbed me again to see if I was hurt. I burst into tears only because he scared the hell out of me. Really, I didn't feel any pain at all! It didn't do a thing to me. Nothing. He was amazed. But then my mother let him have it."

We laugh at the surreal scene as he continues with another story.

"However little, there was always something to eat, mainly pasta and potatoes. Once I served myself a second helping and my father whacked me. I fell on the floor, choking. I can't remember for how long. *Papà* yelled, 'You didn't die as a baby. And you're not going to die now!' Then he turned to my mother. 'Your son who's playing dead, believe me, he's going to have a long life!' And all my brothers burst out in hysterics.

"Father's favorite was Vincenzo, the scoundrel, the oldest. He adored him because Enzo was gorgeous, blond and blue eyes. *Papà* would say, 'He's the most handsome, but the one who'll save us in life will be this one,' and he would point toward me. In the end, I'm the only one who gave and never asked for anything.

"One summer, I got out for a short break and managed to make a small fortune in my usual way, 40,000 liras, which I was saving for my mother. I hid it away in an old shoe on the balcony. A day later, my father noticed the tip of a banknote sticking out. He bellowed, '*Grazia di Dio!* For the grace of God!' He was absolutely sure that the money had dropped down from heaven. That night, he spent all my cash on a great feast to celebrate. I couldn't tell him the truth. But from that day on, I never saved money again!"

Giannino grins, amused, from behind the counter. Angelo winks at him.

"And now we arrive at 1968. The student revolt next to the reformatory created such commotion that I managed to escape. I ran down the street, stole a bike outside a bar where everyone was watching the World Cup between Italy and Germany, and rode like mad home across Naples, without looking back. When my father opened the door, he said, 'What are *you* doing here?' I embraced him hard, telling him how

much I missed him. And he forgave me for running away from school. Then I promised I would go to work and that's what I did.

"But that year my father also got a job—as a carpenter, after all those years with no work, feeling so ashamed and humiliated. Well, it lasted only three years, but he made up for everything, giving it all away to us children, new shoes, treats, you name it. Even his last pack of cigarettes he gave to me. I called it my inheritance. He loved us so much, always hugging us. He knew I was smoking. So he would grab me and kiss me on the mouth to smell for tobacco and then he would belt me. I always denied it. But his last gift was his way of saying he loved me . . ."

Listening to Angelo, it's clear that with all the madness, these Neapolitan families thrive against all odds because of the unquestioned closeness that lies beneath it all. In affluent societies, children drift away, frustrations are never voiced, distance grows, and well-heeled families break apart. Yet here in Naples, blood ties are everything. *La famiglia.* All is on the table. Front and center.

"*Basta*, I wanted to be free, and I grabbed whatever job came along, at the docks, in gas stations, even a pastry shop. I went north to Tuscany and worked making pizzas in Grosseto. But that's another story. Seven months later, I was back in Naples working in a shoe factory. That's when I met my Lucia."

"Your wife?"

"Yes, love at first sight! I knew at once she was for me. But when I asked her to marry me, she just laughed! It took a year before she agreed."

He pulls out his wallet and shows us her photo. Lucia's eyes stare out like deep pools of moonlight. Her natural southern beauty, with dark hair and high cheekbones, suggests not a delicate feminine composure but tough inner strength.

"We've been married now for almost twenty-five years, and she hasn't changed a bit." He lights another cigarette. Smoke circles us. "After our first daughter was born, I landed, by miracle, a steady job with the City." Angelo has uttered the magic words, the dream of every Neapolitan—a monthly paycheck. "And I was assigned to the Sanitation

Department. There are miles of tunnels dug out by the Greeks and Romans when they quarried the stone for our city. Have you been down here?" He taps with his shoe on the floor.

"Not yet, but Angelo, tell me more about your family. Do they like the Caravaggio?"

"They've never seen it!"

"What? Don't they know what it means to you?"

He shakes his head. "I told you, art is a luxury where I come from. Lucia and the girls tease me about it, but I don't mind. Look, Lucia works hard and comes home exhausted, and then has to do the laundry and the cooking. My daughters, well, they've got their own problems. The twins, Maria and Anna, are eighteen and in love with two guys without jobs. They want to get married. My youngest, Chiara, dropped out of school and works part-time in a beauty salon. Her dream is to be a showgirl on TV. The only one who's settled is my eldest, Rita. I don't have to worry about her. She's got a good fella who's a mechanic."

"And no one is interested in what you do?"

He turns his palms up with an ironic smile. "Well, they actually want to see the two of you, not the Caravaggio. Rita wants your phone number."

"We'd love to meet your family—please give Rita my number, and also Lucia."

"I already did." Angelo looks at his watch and leaps up like a rocket. "I've got to run and pick up my wife, sorry . . ."

He drops some coins on the counter and tells Giannino, "For a *caffè sospeso.*"

As he opens the door and rushes out into the cold, Idanna tells me, "You know, he just paid for a cup of coffee in advance."

"What do you mean?"

"For a stranger he's never met."

Caffè sospeso, "suspended" coffee, turns out to be an elegant Neapolitan custom that began in working-class cafés, where someone with a spot of luck would pay the price of two coffees and consume only one. The second would hang there, "suspended." If a poor fellow entered later, asking if there was a *sospeso,* it would be served up free.

"This custom can be found only in Naples," Idanna says with a touch of pride.

"Very classy," I confirm.

"If Caravaggio had known this," she says, "he would have painted it, instead of . . ."

Chapter 8

ILLUMINATED GROTTO

One human life is deeper than the ocean. Strange fishes and sea-monsters and mighty plants live in the rock-bed of our spirits. The whole of human history is an undiscovered continent deep in our souls. There are dolphins, plants that dream, magic birds inside us. The sky is inside us. The earth is in us.

— *Ben Okri*, The Famished Road

Along Mergellina harbor, we stroll up via Posillipo in the company of a silver-haired professor from the University of Naples. With impish eyes, intellectual flair, and humor, Giancarlo Alisio is a close friend of Paola's. Originally from Piedmont, his family moved to Naples when Napoleon's brother-in-law, Joachim Murat, ruled the south. Alisio adores his city and is a passionate historian of architecture. For him, Naples is his whole life.

Alisio wants us to see Palazzo Donn'Anna—a romantic, crumbling stage set of a palace—rising from the blue-green waters of the breathtaking gulf. Its aging façade of camel-colored *tufo* stone is pockmarked with holes, eroded and beaten by waves. Its position on the sea, clinging to the cliff, has inspired a legend that haunts these walls—the spirit of a bygone princess who murdered all her lovers like a praying mantis. One of the city's oldest surviving palaces, it is also one of its most fashionable addresses. We enter the courtyard. From its balconies, the dormant, magnificent Vesuvius can be seen in the distance.

Luxurious apartments are on the upper levels. And all the way down in the bowels of the palace, our guide says, you can find boatmen, carpenters, and fishermen who reside near their place of work, the sea. Below them, an ancient grotto gives shelter to their boats.

As Giancarlo leads us down long corridors and a grand stone stairway, he tells us, "This is a microcosm of the porous web of Naples. Here, the rich and the poor live side by side. The promiscuity of those next to us shapes us, humanizes us. Here, unlike New York, Paris, or London, we are all in the same boat together!" His arms wave in circles.

Idanna leans over the balcony and looks a little farther west to the large Pompeii-red villa where her grandmother grew up in harmony with the rising sun. Below us extends the beach where my father-in-law and his brother Emilio once played with abandon.

"Why is the name Esposito so common in Naples?" Idanna suddenly asks, changing the subject.

The professor nods and then starts speaking of illicit love affairs and moonlit nights and unwanted babies coming into the world. Some would be left in great secrecy at a cloistered convent. Under cover of darkness, the baby would be placed inside a revolving wooden barrel lodged in a wall of the convent. With a single turn of this foundling wheel, the child would disappear forever from sight, and a lone bell would awaken the nuns to the new arrival. The mother's identity would always remain unknown. A baptism would follow. The surname of Esposito was frequently chosen.

"It comes from *esposto,* which means 'exposed' to the elements," Giancarlo says. "Open the telephone directory of Naples, and you'll leaf through pages and pages of Espositos."

My mind turns to Angelo's clan, scattered across the New World from Toronto to Manhattan and down to New Orleans. Even a famed hockey player, who once skated for the Boston Bruins, was called Phil Esposito. All Espositos seem to be related, not by blood, but by ancestral poverty.

Slowly we follow Giancarlo down another small winding staircase that leads into a dark grotto, where fishermen are mending their nets in semi-darkness and flickering light. The hunched men don't even notice us as we pass above them. Walking through a large shadowed archway, we step down gingerly onto the sunlit beach.

"It was not quite the same then," Giancarlo explains, pointing up to the cliffs. "Most of the villas along this coastline were built later. But surely, this is a place where the story of the Pio Monte may well have begun one afternoon, during a picnic on that beach when the young founders rushed for cover in the grotto . . ."

Looking out at the waves reflecting bright sunlight, it's hard to imagine the tempest that shook the group of friends so long ago. I then ask the professor about Caravaggio. He smiles.

"He was a revolutionary." He pauses to let his comment sink in. "It was his nature. His painting was utterly different from his predecessors or contemporaries. He painted people from the lower classes, because he loved them. He was a champion of their cause, one of the first to fight against wealth and privilege, even though he depended on the princes and the cardinals for his commissions."

He speaks of the artist as someone he has met in person, someone whose artistic genius is as strong as his humanity. He reminds us that Caravaggio portrayed the dead virgin as a peasant with dirty feet and a swollen belly, and apparently the model was a young prostitute who had drowned in the Tiber River.

". . . And the monks got so terribly upset, they rejected the painting," he added, amused. "Now it is one of the most important in the Louvre. Caravaggio changed Italian art, which meant changing also the face of European art. After him, Italians and Europeans painted in a different way. He was the wind of change."

With those words we part.

* * *

I ran through a world of shadows. There were shadow beings everywhere. Everything was alive. The objects in that realm shone with eyes.

—Ben Okri, Infinite Riches

In the beach sand by Mergellina, the artist draws a circle, then looks out at the breaking waves. Brilliant sunlight strikes the frothy foam. He hears splashes by the rock, and yelps of joy. Without shame or modesty, young lads swim naked in these waters beyond the city walls. During this "Summer of San Martino," the last flush of heat has lured people of leisure out of the city gates to the cliff sides, seeking cool sea breezes. In this one week of November.

He searches for clues along the wind-sculpted rocks below Posillipo. More than curiosity has pulled the artist here. Yesterday, he asked Marquis Sersale to carefully describe it again: the place where the revelation struck. Ambling over the stones, he searches for the grotto where the seven gentlemen took shelter during the storm. Studying the markings above one cave's mouth, he knows he has found it.

He enters inside the damp darkness and pauses to catch his breath. Recalling the story of his Pio Monte patrons, he senses the moment when the raging tempest changed their lives. Now, it has also changed his.

When the painter emerges from the grotto, he clambers down the rocks, stepping carefully to keep his balance. Alongside the cliffs, a boat with three attractive young ladies floats lazily by. Coyly, they wave at a few gentlemen standing on the rocks, who raise their hats in return. The painter smiles at their tenacity. Daily, he has noticed such "ladies of the evening" parading through the city streets in their sedan chairs and carriages. Tempting sirens. And their admirers call out to them.

Returning to the port, Caravaggio calls to a passing water-seller and pays for a drink. He raises it to his lips as the hunchback points at someone swimming in the bay next to a large skiff.

"That's how they took my Tommasino," he laments. "He was swimming just like that when the sailors accosted him and took him away. My little nephew . . ." The painter hands back the cup, slipping him an extra coin.

An hour later, Caravaggio's path leads him back along the northern city walls. Suddenly he stops before a massive work site that towers above

the hovels. Covered with wood scaffolding, it soars to the skies. For four years, the imposing structure of Santa Maria della Sanità has been rising over the early Christian catacombs discovered by chance thirty years before.

"Here, they will need paintings," he says to himself. But it is too early. In fact, another five years will pass before the glistening sunflower-yellow and sea-jade tiled dome will crown the grand Baroque basilica.

And ten years later, a Dominican cleric will draw up an exhaustive list of relics spread across the churches of Naples. These priceless treasures will include a curious mix—a feather from Gabriel's angel wings, milk from the Virgin's breast, blood from San Gennaro, fragments from Christ's robe, thorns from his crown, nails from his cross. But this is not all. Endowed with sacral power, there are also a number of teeth, bones, hair, and skulls of saints. The bounty mentions a total of 367 complete bodies, 54 heads, 28 arms, and 18 ribs.

On designated holy days of each year, the most powerful relics are carried out in vibrant processions that throb with intensity down the packed streets. Caravaggio has often been swept up in that human tide.

Here it is different than in Rome. Here, you can feel and taste the fervor. And for the poor there will be humbler relics underground, and many more skulls kept in the catacombs, of ancestors still waiting to be found and honored.

These people welcome both the living and the dead. They have empathy with little judgment. A direct human contact with few barriers. Whether among aristocrats in their glittering salons or with the popolo *on the streets, this stranger has witnessed a compassion he has rarely seen in Rome.*

Chapter 9

INSIDE ABRAHAM'S TENT

Remember, the entrance door to the sanctuary is inside you.

—*Jalaluddin Rumi*

*T*he day's work has ended. Caravaggio puts down his brushes. *"Enough!" He wipes his oil-stained hands and looks up at the skylight. Twilight has fallen. He locks the door and walks quickly down the street dimly lit by the oil lamps flickering from windowsills. He crosses Piazza San Domenico Maggiore, passes the great Basilica Santa Chiara, and approaches the Cerriglio, a ribald watering hole where he often finds other artists, poets, and travelers.*

He slows his gait. Something strikes him. A man with a red beard and a walking stick stops in front of the entrance. He is fatigued, as if he has walked for days from afar. At that moment, 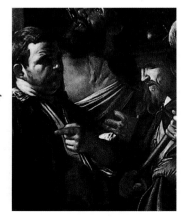 *the plump tavern keeper steps out, spots the exhausted stranger, and invites him in. Caravaggio's eyes focus on the light pouring out of the tavern. The sacred act of hospitality.*

In ancient Greek, philoxenia, *or "love of strangers," was rooted in the belief that each traveler could be a god visiting in human form.*

In Jewish tradition, a hospitable person is said to have "the doors of Abraham." To

this day, this Patriarch's tent remains a sacred icon—open flaps on all four sides to better let in guests. When Abraham first welcomes three strangers to his tent near Sodom, there is no mention in the Torah *that they were angelic. Hasidic teachers believe that Abraham saw the divine in everyone.*

In the Zagros Mountains of southern Iran, the Bakhtiari tribes call the traveler "a gift from God." In the eastern islands of Indonesia, a stranger is never turned away. In the Arabian deserts, travelers are given three days' food and shelter: it is law. Muslim Hadith tells us, "God created different tribes because he wanted us to know one another."

Along the Ganges, Atithi Devo Bhava *in Hindi means "the guest is equal to God." The Hindu tradition of hospitality declares, "What you are, I am." The Jains believe that "Only if you recognize the divine within can you recognize the divine in others."*

In Ireland, the medieval poem "Rune of Hospitality" reminds the Celts: "Often goes the Christ in stranger's guise." And in the gospel of Luke, we read the parable of the Good Samaritan. Traditional enemies of devout Jews, Samaritans were not often cast in sympathetic light. But in the story, the Samaritan not only rescues a man left beaten by robbers by the roadside (after two neighbors have passed by), but he takes him to an inn. Before departing the next morning, the Samaritan gives the innkeeper his coins, saying, "Take care of him and whatever you spend beyond that, I will pay you on my return."

After Jesus tells his parable, he then asks the crowd, "Who is this man's neighbor?" A voice answers, "The one who showed mercy."

Two thousand years later, the philosopher Ivan Illich points to the deeper meaning of the parable. "Your neighbor is not bound to you by tribe, faith, or ethnos. You are free to choose, to love, to reach out. You are free to be moved by compassion."

On this night, standing outside the Cerriglio tavern, Caravaggio recognizes in the beleaguered pilgrim the man from Nazareth.

In that same moment, the innkeeper beckons the pilgrim to enter.

This is what Caravaggio will paint.

The threshold is lit.

Chapter 10

Origins and Ancestors

Servile Italy, hostel of grief,
Ship without a captain in a great tempest,
Not a lady of the province, but a bordello.

—*Dante*, Inferno

"Let it all be a mystery," Paola says over dinner. "Here, in Napoli, you can never be sure . . . And also, please don't let him know where I live."

As I devour her delicious *melanzane alla parmigiana*, succulent eggplant with ripened tomatoes, she insists we keep distance from Esposito. Then she drops a remark about the dangers of "crossing boundaries." I hear the French term *"voyeurism."* Then she adds, "you never know." Paola draws firm lines of demarcation in the society of her town and wants us to do the same. In today's Naples, now plagued with petty criminality, people have learned to live with fear.

Idanna diplomatically steers the conversation away from Angelo, not wanting to preoccupy her friend. Clearly, she and Paola don't see eye to eye. Idanna puts the travails and suffering of Caravaggio's life and Esposito's on the same level. Paola does not.

Once our hostess heads off to bed, Idanna turns to me and asks, "Why make a difference between the two? Caravaggio wouldn't. After all, a life is a life. It's the people who count," she insists. "Only people draw you to stay in a place, no matter how risky and hopeless it is,

not just the monuments." Before turning in, we take one last look at the bay.

It is well past midnight. Standing on the balcony, we stare out into the distance and beyond. In the darkness, across the gulf, myths surface like dreams, remote lights flicker from ancient times.

Here, classical Greece planted roots beyond the Aegean shores. According to legend, Ulysses spurned the love of Parthenope, and the broken-hearted siren threw herself into the sea. Her body washed ashore in the Bay of Naples. When Greek immigrants from Rhodes first disembarked, they anointed their new settlement in her honor. The city's first name, Parthenope, is rooted in abandonment, just like Esposito's family name.

Adored by Romans for its delicious climate, lemon blossoms, and stunning vistas, the site soon became an Epicurean retreat. Cicero called it "the bay of luxury." Tiberius ruled the empire from his pleasure palace in Capri, while prized villas along the coast attracted senators and sybarites to a playground of earthly delights.

On occasion, the gods took exception. Vesuvius exploded in anger, petrifying nearby Pompeii and carbonizing Herculaneum. Spartacus and his rebel army sought refuge on the volcano's high slopes. An African prince, Hannibal, laid siege to the city. Brutus, in his villa, plotted the assassination of Julius Caesar. In Posillipo, the sacred poet Virgil still lies asleep in his tomb. And here, the last emperor of Rome, Romulus Augustulus, died in exile.

Once the center of Magna Graecia, Naples emerged from antiquity as an exquisite plum to be plucked by foreign invaders. Blessed with unearthly beauty, the city could never defend itself from ravenous suitors who invaded at will. The list is long.

With the collapse of Rome, the Byzantine Emperor Justinian in faraway Constantinople launched a crusade to reunite the empire. His general Belisarius raged at this Hellenic city that would not renounce its allegiance to the fledgling Church. In 542, the Byzantine army marched inside the walls and put every citizen to the sword, exterminating the entire *polis*.

Riding through the empty city and facing the void in the piazzas and buildings, Belisarius was struck with remorse. He ordered nearby

villagers to be brought by force from Summa and Salerno to repopulate the city. Byzantine historians cleansed his name until recently, when the papyrologist and classical philologist Gianluca Del Mastro uncovered the genocidal truth.

Strategically situated at the crossroads of Europe and Africa, Naples has been trampled and occupied by a parade of foreign powers—Goths, Normans, Angevins, Swabians, Aragonese, Spaniards, French, Austrians, Americans—almost continuously for over two thousand years, which leaves open the question of what is really Neapolitan.

Long gone are the heady days when the city's classical treasures and its jaw-dropping natural setting were the must-see Grand Tour highlights for young, well-heeled eighteenth- and nineteenth-century English and German aristocrats and artists. Byron, Shelley, Goethe, Stendhal, and Mozart all flocked here as cultural pilgrims. Intoxicated by the exotic romance of it all, they sighed, *"Vedi Napoli e poi mori."* See Naples and die.

Alas, today the saying has been transformed into *Vedi Napoli e Scappa*, or "See Naples and flee." Degradation has taken hold. The stench of rotting garbage symbolizes the Camorra's cancerous corruption. Entrenched poverty and widespread unemployment are birthrights. The Neapolitan writer La Capria asks the obvious question, "Will Napoli always be a sick city, the kitchen rag that absorbs all the disgraces of the south?"

Angelo's reaction when asked about the glories of the past taps a sensitive nerve.

"Glories?" he answers indignantly. "How many times have we been invaded? *Mamma mia.* All those foreigners—well, we got a piece of each of them."

"Except for that time of Greeks and Romans, you aren't talking of Neapolitans but of occupiers. But we Neapolitans always bought and sold what they couldn't nail down." He slapped his chest in defiance. "We're specialists in *arrangiarsi*—the 'art of making do.' We've got *furbizia* in our blood, a cleverness that no other Italian seems to possess. That's why we're experts in dealing with foreigners, because we're cosmopolitan."

Luigi Barzini, the sage author of *The Italians*, sums it up. "In Italy, life is more or less slowed down by the exuberant intelligence of the inhabitants." Here in Naples, I've come to realize, life is paralyzed by it.

Today the city is again held hostage, but this time not by foreigners, but by predators from within. The culprits are part of the ongoing circus that calls itself "Italian politics"—compromised ex-communists or ex-fascists—all making deals with the secret societies. Observing the effects of the twenty-year reign of Berlusconi and his Sicilian allies, you realize how organized crime secured the highest realms of power, with America's full blessing.

In fact, most Sicilians will tell you that the Mafia's power was reestablished when the Americans landed in 1943, bringing the mobster Lucky Luciano from New York to cement ties. Ever since, the Mafia has loyally served as the US militia, quieting any criticism from the Italian Left—even assassinating pesky politicians, if need be. Seventy long years later, America has yet to pay one dollar in rent for their seven military bases in strategic Italy, poised for action in conflict zones across the Middle East and North Africa—while for the same use of the naval base at Pearl Harbor, the US government pays an annual rent to the state of Hawaii.

One also cannot overlook the notorious Masonic Lodge called P2 and its grand master, Licio Gelli, a declared fascist who plotted the overthrow of the Italian Republic in the 1970s. The P2's secret membership included military commanders, Mafia chieftains, captains of industry, leaders of the security forces, and Vatican financers. After Licio Gelli was indicted for murder and conspiracy, he fled to Argentina. Years later, Prime Minister Berlusconi, an inscribed member of the lodge, granted Gelli amnesty and he returned. In the left-leaning newspaper *La Repubblica,* Gelli confirmed that his P2 "democratic rebirth plan" was already in place across Italy.

Every morning I look at the country, read the newspaper, and think: all is becoming a reality little by little, piece by piece. To be truthful, I should have had the copyright to my plan. Controlling TV, public order, and justice, this is what Italy needs.

Any fearless priest who decides to break the code of silence, or *omertà*, about the Camorra's hold on Naples pays a heavy price. Don Diana, in a dramatic speech before his congregation in March 1995, denounced the Camorristi as "terrorists" and condemned their criminal practices. He paid for it with his life. They gunned him down in front of his church. His death inspired journalist Roberto Saviano to begin writing his blockbuster, *Gomorrah*.

In Spaccanapoli, blocks away from the Caravaggio painting, a notorious clan has held the entire quarter of Forcella in its iron grip since a black-market bazaar flourished there after the war. Saviano explains:

> *The Giuliano clan was born in Forcella . . . a neighborhood shrouded in casbah mythology, the legendary rotten navel of the old city center . . . from smuggling to prostitution, from door-to-door extortion to holdups . . . Even today whoever wants to operate in the city center has to square it with the Giulianos. A clan that still feels poverty breathing at the back of its neck . . .*

Esposito tells us about Padre Luigi Merola, the new, charismatic thirty-two-year-old priest of Forcella, who looks like George Clooney and has a sense of social justice.

"A man came up to him and snapped, 'Stop speaking about the law, priests have to speak about God.' You see, they've given him a warning. Now watch, Rome will transfer him."

Angelo proves to be right. Don Merola would soon be transferred far from his flock to Rome, where his brave work would be neutered. In the end, the Vatican has always been ambivalent about the rampant criminality. Confessions and pardons cleanse the crimes. Communion without demanding conversion and a change of life condones such behavior. In return, donations enrich the local parishes. Yes, there are many such courageous priests across Italy. But they are alone. Shamefully, the Vatican prefers to ignore the blight of organized crime across society. Yet Angelo is certain of one thing: a blanket excommunication of all Mafiosi would turn the entire system on its head.

Sadly, Hollywood has glamorized these mobsters in the public imagination. Of all the Mafia films, perhaps Coppola's epic of *The Godfather* did the greatest damage. Through the stylish acting of Brando and Pacino, brute violence and criminality were celebrated under the guise of "honor and respect." Ironically, the original inspiration for Mario Puzo was not a Sicilian, but a Neapolitan: none other than Alfonso Tieri, a boss from Pignasecca in downtown Naples, who later headed one of America's leading Mafia families.

The Mafia has a long tradition in Italy, but during the twenty years of Berlusconi's reign, the marriage between Italian politicians and the Mafia bosses was consummated under one roof. Everyone in Naples knows that each time politicians speak of "solving the garbage crisis," they can only do it by talking to the right people.

There is an old legend of the three Mafias that curse Italy, more precisely the regions of Sicily, Calabria, and Campania with Naples. The origin myth begins around 1400, when three Spanish mercenary knights from Toledo called Osso, Mastrosso, and Carcagnosso (Bone, Master Bone, and Heel Bone) took refuge on one of the islands just off northwest Sicily. There they agreed to found Sicily's *Cosa Nostra*, Calabria's *'Ndrangheta,* and Campania's *Camorra.* Then they went off to plant their seeds. And now the descendants of Carcagnosso are putting the screws on Naples.

The Sicilian writer Leonardo Sciascia once described the slow northern advance of the Mediterranean palm tree up the Italian peninsula. He felt it was a potent sign; an irrefutable confirmation that the south was slowly conquering the north, however imperceptibly. He also made a prophetic statement in 1964. He insisted that Sicily would not become more Italian, but rather that Italy would become more like Sicily.

When I ask Angelo what he thinks of Bassolino, the former mayor and governor of the region with a reputation as an anti-Camorra crusader, he laughs.

"He's alive, isn't he? If he had done anything against them, he'd be dead."

A tired church bell tolls above us.

"Terenzio," he adds, "Neapolitans crack jokes even on their deathbeds. But, in the end, we are not alone." He raises his arms forming a circle. "We have the spirits of our ancestors always beside us, above us, and below us!"

Chapter 11

INTO THE UNDERWORLD: NAPOLI OF THE SPIRITS

This is the true joy in life: being used for a purpose recognized by yourself as a mighty one; being thoroughly worn-out before you're thrown on a scrap heap; being a force of nature instead of a feverish, selfish, little clod of ailments and grievances complaining that the world will not devote itself to making you happy.

—*George Bernard Shaw*, Man and Superman

With each new dawn, the thermometer rises. Sirocco winds carry a burning breath from the Sahara and the punishing sun hovers over the city, sizzling all it strikes.

Abandoning the heat, I follow the guardian into the dark, humid maze of passageways carved under the Basilica of Santa Maria della Sanità, the same church that rose over the catacombs during the age of Caravaggio.

A delicious wave of cool air washes over us. Having Angelo next to me makes even the strangest sights feel almost normal. This is his world. As we penetrate further, I see human skulls carefully stacked in different corners on volcanic-earth shelves. Angelo says that some of these souls are celebrities among Neapolitans.

A middle-aged woman shuffles by in the dim, candlelit darkness. I can't see her face but can sense she knows her way around.

"When someone adopts a skull, Terenzio, it's like adopting a real person," my friend says in a hushed voice.

I listen in silence.

"Watch her . . . see what happens," he says, gesturing with his eyes. "She'll light a candle and begin talking." And sure enough, the woman does exactly that. She caresses the skull and places a rose in front of it. The flame glistens in the sockets as invisible eyes stare out.

"If my prayers get you into Paradise," she urges softly, "please help me."

All these skulls gathered here over centuries belong to victims of plagues, famines, earthquakes, and other disasters.

"None of them received a proper burial. The population of our unburied ancestors stretches across Naples," Angelo points out.

Other visitors arrive, lighting their way with small torches. They move quietly. I overhear a voice.

"That old woman," Angelo confides, "comes here to visit Concetta, who's famous for helping out women."

We listen as the grandmother moans aloud to her guardian angel about her son's cancer, and what will his kids do without him, and all her financial problems.

"Concetta's reply always comes later," he tells me. "Souls speak in dreams. That's why dreams are so crucial for us. They give us all the clues! Our ancestors are always at work."

We walk south and leave the quarter of Sanità, known as the "valley of the dead." Back in Spaccanapoli, we stop at the small church of Santa Maria della Anime del Purgatorio—Saint Mary of the Souls of Purgatory. Sculpted into the exquisite wrought-iron railing leading to the entrance is an assortment of tiny skulls.

Inside, it is cool and dark. Through an opening in the floor, we descend down steep stairs into the crypt. Along the sidewalls are niches and small altars. At the foot of one shrine lies a collection of memorabilia—thank you notes, letters, and photos. Here too a woman's voice rises in the candlelight.

"Lucia, Lucia . . . *anima mia* . . . *Grazie!*" She is thanking, with all her heart, the soul of a certain Lucia, softly touching a skull covered with a veil. To Lucia's left and right side are two other skulls, like maids-in-waiting.

"Some say that Lucia was a princess," Angelo recounts. "Others believe she was just one of us. But Lucia grants favors only to those

who are honest and sincere. When a favor is granted, you've got to thank her!"

Among all the lost souls, he tells me, the most beloved is the famed Lucia.

This secret cult—rooted in the beliefs of the ancients that souls reside in all places—thrives in Naples. By adopting an abandoned skull, lovingly cared for it, alleviating its pain, the devotees not only perform an act of mercy, but something comes back in karmic return—protection and help from the other realm.

When we surface into the blinding light, I ask, "Angelo, why do Neapolitans call their city Purgatory?"

"Well, it's the place of passage and punishment, where we expiate our sins and hopefully get ready to move on to heaven. That's Naples."

We head for the bar across the street. There too, Angelo seems to be a habitué. While I sip a glass of red Piedirosso, my friend describes the odd group of fellows at the next table.

"La corte dei miracoli . . ."

I know what he means. The term "court of miracles" originated in Paris, where a whole gang of vagabond thieves and beggars—which inspired Victor Hugo's *Les Miserables*—lived together with their own hierarchy, slang, and even a king who ruled over his court. Many of the lame and blind who begged in the city by day could be seen at night walking back into their slums. Such "courts of miracles" became legend across Europe.

"Well, that one is a petty thief, very clever." Angelo knows all of them well. His friend, missing a leg, specializes in picking pockets. "The other guy is deaf and dumb but the smartest of the lot, and the wisest. He is always trying to convince them to stop. The guy, standing, was a junkie . . . he has now quieted down. They're all past thirty, and not one of them has ever held a steady job."

We overhear the small-minded thief speak up in a voice gravelly from chain-smoking. "Last night," he tells his buddies, "I dreamt of holding a dying man in my arms, you know who it was? Christ! His face was wet with tears. I asked him, 'Why are you crying?' He replied, 'Because of all the terrible things that happen in the world.' And I woke up and

couldn't fall asleep again, thinking of the situation we've put God in. It's a mess. When I ask, 'Help me steal this motorbike,' I know there's another fella begging, 'Please, don't let anyone steal my Vespa!'"

He slaps his thigh, looking our way. "Angelo, tell me, what would you do if you were God? It's a hell of a mess!"

"That bloody dream gave you the license to steal! That's what I think!" protests the guardian.

"Yeah, you went straight out to rob the next morning!" yells the junkie.

His deaf and dumb friend mumbles something that sounds like "Shut up you crazy!" But I can't be sure. "*Basta*! Enough!" he yells.

"Yeah, they're all crazy!" Angelo shakes his head as the motley crew bursts into playful insults.

* * *

Fiery streaks of sunset now linger for hours as bats join the seagulls circling in twilight. Each night grows on the horizon like a mountain of smoke and then, slowly, it crumbles over us like a wave.

In the heat of the day, we trace our way back to reconnect with Angelo at the Pio Monte Church. It's almost noon. He announces his plan to give us a glimpse of the seven acts of mercy being played out in his city. Together we walk over to a nearby grime-streaked Baroque monastery. The grand portal is padlocked and rusted. Around the corner, however, a crowd waits in line for a side door to open.

As the bells ring above in a cacophony of sounds, a sister from the order of Mother Teresa of Calcutta appears, in her white muslin cloth with thin sky-blue stripes, and opens the side entrance. The orderly people climb up the few stairs and enter a spacious courtyard where food is being served.

"They're all *extra-comunitari,* from Ukraine and Romania," Angelo tells us. This word has a distinct negative ring to it. These men and women are the "illegal aliens" of Italy.

"Just imagine, Naples has become a city of immigrants!" he goes on. "Call your friends in America, Terenzio, no one will believe you!"

An Indian nun strides over and greets Idanna with a radiant smile.

"Sister, where in India were you born?" Idanna is curious.

"Kerala," she replies, "in the south. There's so much to do here. We feed about a hundred mouths every day. So many from Eastern Europe and even more have crossed over from Africa this year."

"More than last year?"

"Yes," she answers, her eyes as gray as the Ganges. "We welcome everyone. Please sit down with me," she says, gesturing. On the faded pastel-blue wall, a poignant poem by Mother Teresa is written for all to see.

Man is irrational, illogical, egocentric,
Never mind, you must love him.
If you do good, they will accuse you of having ulterior motives,
Never mind, you must do good.
If you succeed, you will find false friends and true enemies,
Never mind, you must persevere.
The good that you do will be forgotten tomorrow,
Never mind, you must do it.
Honesty and sincerity will make you vulnerable,
Never mind, you must be transparent.
All you have struggled to build can be destroyed in one moment,
Never mind, you must build.
If you help people, they may resent it and turn against you,
Never mind, you must help.
Give to the world your best, and expect the world to kick you back,
Never mind, you must give.

Over a bowl of minestrone and bread, Sister Gita excitedly tells us a marvelous story about Mr. Hari Ahuwalia from Calcutta who had come to sign the official "sister city" pact with Naples. He also happened to be a member of the first Indian expedition to Mount Everest. But now he moves with a wheelchair after being wounded on the Indian-Pakistani border. Along the bay on the Riviera di Chiaia, two youngsters speeding by on a scooter mugged him and

even managed to steal his gold watch. This was two days before his flight back to India.

"Believe it or not," Sister Gita says excitedly, "I heard he got his watch back!"

Esposito leans over. "It's true, it was in the news! He got it back. But not because the thieves 'repented' but because the cops went into the Spanish Quarter where many of these guys hole up, and they threatened to stay there forever. The next day, the cops got the call they were waiting for. The watch was left in a bag . . ."

"Imagine, when the police at the airport in Rome handed the watch to Mr. Ahuwalia," the sister says, smiling, "just as he was boarding the flight!" She makes a sign of the cross.

"That reminds me," says Angelo, "let's go over to the Spanish Quarter. I've got something else to show you."

We take our leave of the gentle sisters and find ourselves again on Via dei Tribunali. Angelo picks up his pace. We follow him blindly, like sheep behind their shepherd, into the infamous grid of menacing alleys. Known as the *tavoliere,* or chessboard, this urban web was laid out in 1536 by the first Viceroy of Naples, Don Pedro de Toledo, to house his hated Spanish soldiers. Today it is a grim piece of real estate, the squalid stronghold of the Camorra Russo clan.

Walking briskly, Angelo explains the origin of the word *"camorra."* It may come from *chamarra*, the short, loose Spanish cape worn by the Lazzaroni street gangs who thrived during Caravaggio's days. Then again, others say it comes from the Spanish word for "brawl or cross swords."

In any event, this neighborhood is known to be theirs. Eyes follow us. Scooter riders slalom around pedestrians. Here, no one wears mandatory helmets. All faces have to be seen. Any concealed face is presumed to be an undercover cop.

Crumbling old palazzos bristle with TV antennas. Laundry lines lace the alleys and gusts of wind send shirts, towels, and sheets flying overhead.

"School has closed for the summer," Angelo tells us. "If we'd come last month, you would have seen *la scuola di strada* in full action. Children would be gathered in this garage, improvised as school!"

He describes a true Neapolitan hero, Marco Rossi-Doria, who created this so-called street elementary school to give kids a way out. Everyone calls him *maestro di strada* or street teacher. Marco is known throughout Italy. From Naples, he traveled to Richmond, California, to work with impoverished kids. After working in Kenya for two years in the slums, he taught in the poorest quarter of Rome, and then decided to bring his experience to his native city and offer hope to children who drop out of school even before they begin.

Angelo seems quite at home here, as if he knows the neighborhood well. He calls over to a small boy with spiked hair and a torn Rolling Stones T-shirt.

"Meet my friend Giulio. He's a good kid, one of the students." Angelo rests his arm on the boy's shoulders. "The key is putting street smarts together with school smarts. When I have time, I hang around with these kids. When one or two come with me to the Caravaggio, I am really happy. Already a few know what's happening in *The Seven Acts*."

Turning the corner, we encounter a small group of women with infants in their arms. They are pressed around a spirited young female in a white medical smock. A three-wheel van called *Ape*, Italian for bee, is the mobile dispensary parked sideways next to her.

"Many here stay away from hospitals," Angelo confides. "They don't have identity papers, and don't want to be legal, in any system. *Capito,* understand?"

Meandering out of these alleys, I notice that the guardian always walks on Idanna's left, the side nearer to the street. He insists that she carry her bag on her right shoulder, along the buildings. Neapolitan gallantry. In this way the men protect their women from purse-snatchers speeding by.

At one broad intersection, a maelstrom of traffic sweeps around us. Waves of motorbikes and cars swarm by at hyperbolic speed. Amid the chaos, a taxi driver leans out to yell at an obese boy also stuck in the middle of a crosswalk.

"Tell me, you prefer to eat pasta with the spoon or the fork?" the cabbie shouts at the chubby kid. Angelo chuckles at the cheeky line while dodging a motorcyclist without breaking stride.

Finally we arrive at Piazza Carlo III, dominated by the *Albergo Reale dei Poveri*—the Royal Hotel for the Poor—also known by the name of the brilliant Florentine architect, Ferdinando Fuga, who designed it. Palazzo Fuga is one of the most monumental seventeenth-century buildings in Europe, with a grandiose 400-meter-long façade, simply astonishing in scale. The building covers ten square blocks.

"The last earthquake in 1980 was so strong," Angelo recollects, "that inside there, the walls cracked and ceilings caved in. All the people were relocated. Then, of course, the Camorra moved in like hyenas, stripping all the fixtures, marble, wood, door handles."

This marvel of architecture—a visionary project of Carlo III, the progressive Bourbon King of Naples and the Two Sicilies, the only king whom Neapolitans seem to respect—was completed in 1751 as an ambitious plan to deal with the kingdom's widespread poverty. It was a city within a city, conceived to house about eight thousand people. The homeless, herded inside, were never allowed to leave. Neapolitans still refer to it as *O' Serraglio*—the place to domesticate exotic animals.

Men and women resided in separate quarters, meeting only in church. Occasionally families were formed. Over time, the workshops in this gigantic "menagerie" would train master carpenters, blacksmiths, leather workers, weavers, embroiderers, upholsterers, candle-makers, and bakers, who worked without ever setting foot outside.

"You should see what happens in this piazza at night. The place turns into a campsite of homeless and drifters. And inside, well, it's all abandoned, except for . . ." Esposito stops in mid-sentence, and gestures on.

We enter a wide dark tunnel that runs under the palace. African winds may have warmed the city, but here it's chilly. Another tunnel cuts to our right. Cigarettes glow red at the far end.

"Junkies," warns Angelo. "The Camorra uses this place for their pushers. It's off-limits to cops."

He looks over his shoulder. His neck moves with a nervous twitch. Our heels echo in this huge cavity. We approach a shining light ahead. Angelo keeps scanning the shadows until finally we reach a large opaque glass door. He pushes it open.

Before us, under crisp florescent lights, lies a grand, pristine-clean sports center. Blue-padded exercise rooms with smooth wooden floors open to the right of a central corridor. In one gymnasium, two ball-room-dancing couples glide across the parquet to Cole Porter's *I Get a Kick Out of You* like Astaire and Rogers. Angelo turns a sharp left and barges into an office, calling out, "Peppe!"

Muscular Giuseppe Marmo rises from his desk to hug his friend. His smile is pure sunshine; he grips my hand with uncommon strength, while a little African girl with huge eyes grins at us.

"My little treasure!" he rejoices, picking her up in his arms. Angelo immediately prompts him to tell the story of his Kodokan Club.

"It's part of a project called *Città dei giovani*, Youth City. We try to pull kids off the streets through martial arts and give them a sense of discipline. It's not easy to save them from the Camorra. We've got to first enter the gangs that roam like wild packs, and then if we gain the trust of just one kid, we're happy." Peppe reaches out like a hunter and grabs at the air.

"The *Camorristi* use kids as couriers to deliver drugs because children can't be arrested. Eight-year-olds bring in more money than their parents, even when Mom and Dad have jobs. But once they are four-teen, it's all over. The mob tosses them aside, and all they can do is join street gangs and live by stealing. That's when I try to pull them in."

He pats his chest. "Angelo and I had the same childhood. In reform school, I was lucky to find karate. It changed my life."

Above his curly black head hangs a photo of an Olympic award ceremony in Seoul, 1988, with a younger version of Peppe in his white karate uniform. His bronze medal catches the light.

Thoughts race through my mind. How does Peppe finance all this? The city contributes only pennies. In Italy, private donations are not yet tax-deductible, because the government doesn't trust its citizens and vice-versa. Often foundations are only used as ATMs and for tax evasion. But in Peppe's case it's so different. How does he manage to do so much with so little? Even adopting this Ethiopian child, adding another mouth to feed in his household with three children of his own? A photograph of his lovely wife, smiling serenely, stands prominently on his desk.

"She's like me. We give it all we have. I can't imagine doing any other type of work in life." He exudes tenacity and unbounded commitment. Peppe has a long-term plan. For every child he saves, there is a future. Each is an example to those left behind. In time, a few other kids may show up looking for Marmo to train them in martial arts. Some may even end up, in the future, doing the unthinkable: joining the "other side," becoming *carabinieri* or policemen.

For those who believe that the Camorra is exclusive to Naples, it's enough to know that with an annual turnover three times larger than Fiat, its influence reaches across the ocean to Washington, DC, and Manhattan, even in the reconstruction of the new World Trade Center. In the past three decades, the "system" has taken more lives than al-Qaeda, one life every three days.

Leaving Peppe's underground world, Idanna muses that Marmo should be nominated for the Nobel Peace Prize.

His acts of mercy have lifted up so many, with such far-reaching consequences.

"Imagine," Idanna says, "what he could do with that million-dollar prize!"

Chapter 12

THE CLOAK OF ST. MARTIN

Naples isn't simply a city; it is a part of the human spirit that I know I can find in everyone, whether or not they are Neapolitan.
— *Luciano De Crescenzo*, Thus Spake Bellavista

A wind blows outside the chapel as Caravaggio crosses the crowded piazza. He feels a strange pull on his leg. Looking down, he sees a half-naked man on the ground. A sharp ray of sunlight shines on the beggar's bare back. The painter throws his cape over the shoulders of the man whose eyes widen with surprise, especially when the stranger kneels beside him.

"I need you, good man," Caravaggio says as he carefully helps him stand up. The beggar does not resist and hobbles on with the stranger, who leads him into the chapel. The painter sits him on the floor, pulls a freshly baked loaf of bread from a satchel, and breaks it in half, handing the biggest piece to his guest.

A man of few words, the maestro now shares his thoughts aloud.

"Listen my friend, do you know that Christ lived among the poor and the sick . . . Not with the wealthy lords or high priests. The meek, he said, will inherit the earth. He chose to live among the unwanted so he could feel their pain. How else could understand the human condition?"

The beggar listens with a baffled look on his face.

"Forgive me, I want to paint you with your back turned toward me, half naked as you were out there in the street. Sit down with your legs to the

*side and the soles of your feet also toward me." Caravaggio removes the cape
from the man's wide shoulders. Then he picks up a brush.*

*"Light his back!" the maestro orders his young apprentice, who posi-
tions the mirror. Caravaggio outlines a twisted torso with illuminated
shoulder blades in white lead paint. A blood-flushed hand supports
the body's weight with great effort. A foot drags in the dust. The figure
takes shape.*

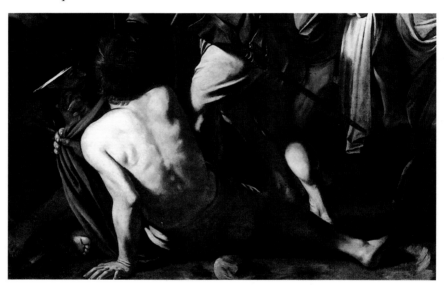

*The painter turns to a waiting young man dressed in the costly finery of
a knight and gestures to him.*

"Please, it's your moment. Walk slowly by this poor man."

The model obeys.

*"Look down towards him." The painter commands. "Yes, like that! Now,
your cape . . ."*

*The knight slices his burgundy cape in half with his sword. The cripple
at his feet pulls on the fabric. According to the custom of the kingdom, a
soldier owns only half of his garment. The other half belongs to the state.
The knight gives away his own half.*

"Good! Perfect!" the artist cries.

*All know the story of Saint Martin, a soldier in the Roman legion. In the
dead of winter, he gave a beggar his cloak.*

The elegantly robed knight can't keep his eyes off the good man on the ground. His expression is one of deep compassion and sadness. And in that moment the model and the soldier become one.

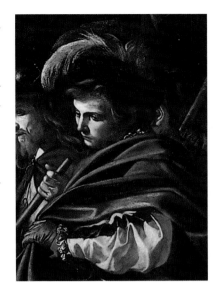

Like Saul on the way to Damascus, he is visibly shaken. He stands frozen in his tracks. Stunned, not feeling the cold, in sacred awe.

Chapter 13

Goya and Lion Masks

We are all prisoners but some of us are in cells with windows and some without.
—*Khalil Gibran*, Sand and Foam

Each Friday, the seven governors of Pio Monte gather to pray together before Caravaggio's *Seven Acts of Mercy*. While the priest officiates, Angelo leaves the church. This is their ritual, not his. After the ceremony, they climb the palace staircase up to the offices for their weekly meeting. Then they break bread and have lunch together.

Angelo's portly, heavy-lidded colleague in the church couldn't care less what the governors do. As a city employee, Pierino says, it's none of his business. Besides, he welcomes every chance to slip out for a coffee. But for our friend it's different. He looks at these modern-day aristocrats with a certain admiration, because they choose to walk in the same footsteps of their ancestors, founders of the Pio Monte.

Today, he suggests that I meet Salvatore, who works at the institution where two governors will be visiting.

"So, Terenzio, shall we kill two birds with one stone?" he says with zest. "You can see a place that is under Pio Monte's wing, where one of the acts of mercy is performed regularly, and also you'll meet Salvatore, a really great guy."

* * *

In the teeming crowd, two of the seven governors of Pio Monte walk briskly. One sports a fine copper-hued fedora. The other is smartly dressed in an auburn coat. They have an appointment to keep. They head up Via Salvator Rosa, turn onto Via Matteo Renato Imbriani, and stop in front of the old monastery of Sant'Efremo, converted into a prison in 1927. Above is written, *Ospedale Psichiatrico Giudiziario*, Hospital for the Criminally Insane. A police van stands parked. The governors salute the officer standing in front, seemingly half asleep, who replies warmly.

Marquis Fernando de Montemayor and his colleague, the eminent lawyer, Marquis Mario Pisani Massamormile—both Knights of Malta—stand calmly before the gate as Angelo and I arrive. They recognize Angelo and say hello. I introduce myself just as the guard opens the gate. We all enter, and the two gentlemen bid us good day before disappearing inside behind another door. Everything happens so quickly that they don't even seem to wonder what Angelo is doing there instead of being at the Pio Monte Church, and in the company of a foreigner.

Angelo lights a cigarette as we wait in the entrance for his friend Salvatore. Ever since the guardian came to understand the altarpiece, he has been interested in finding out where and how the governors administer their acts of mercy.

"You see, Terenzio, here they come every week to visit murderers, psychopaths, lunatics. There are 130 inmates here, all convicted for violent crimes and judged insane by the State. Whether possessed by demons or driven mad by jealousy, every prisoner is in for life."

With a hint of pride, Angelo says that a few governors are actual descendants of the original patrons of Caravaggio. An unbroken line to today.

I tell the guardian about our earlier meeting with the President of Pio Monte, Marquis Riccardo Sersale, whose ancestor Cesare Sersale was one of the founders. During our visit to his home in Posillipo, Idanna was a bit surprised to find out that our host was a renowned university professor of chemistry. On the other hand, I was amused to discover that his younger brother, Franco, owns the famous *Le*

Sirenuse in Positano (a favorite hotel of Steinbeck, Ingrid Bergman, and U2, among others). A passionate traveler, Franco spent years working in Tehran before the fall of the Shah. When I leafed through his remarkable book of photography, I saw humble, dignified faces from far Samarkand, Isfahan, and Kashgar staring out at Franco's lens from an innocent epoch, long before darkness fell over those benighted lands.

Angelo takes a drag of his smoke and now tells me about his buddy, Salvatore Fuso, who will take us inside. About four years ago, Salvatore had had enough of working for a big bank in Rome, and followed what his heart told him. He changed his life. He heard through the grapevine that no one wanted to work at Sant'Efremo, so he decided to come back to his native Naples and take up the challenge.

And it is he, Salvatore, a gentle soul with glowing eyes, suddenly enters and greets us. His elongated face is crowned with a mane of silver-streaked hair. He gives us a big welcome and starts speaking about his work. He teaches art to the inmates, and proudly leads us through the domed interior of the atelier.

One of his prize "pupils," Peppino, has just finished a striking terra-cotta mask of a lion's face with hair flowing in all directions. The young man is in for two homicides. Masks are quite popular among the inmates. On a table stand three brilliant terra-cotta faces, ready to perform in a classical Greek tragedy. Another inmate likes to paint only monsters. Fuso refers to him as Goya, because Goya always painted monsters in black and white.

Salvatore then picks up a special artwork, also in terra-cotta, to show us. It's an old, ruined brown boot, one that has walked for years, and from the open sole in front, a red tongue sticks out.

"Very strong." Angelo says, admiring it. We agree that yes, this is not a boot we will easily forget.

"He has named it *Fame*, hunger," announces Salvatore.

"*Mamma mia.*"

"Art is actually one of the only ways through which a troubled soul can express what he carries inside," the teacher points out.

"He must have suffered a lot of hunger," counters Angelo.

"Well, this weekend I'm taking Peppino home for lunch," Salvatore tells us, referring to the young inmate who made the boot. "My wife is going to prepare something special."

"You've got courage. I could never convince Lucia or the girls to let me bring home a murderer . . ."

"But you can't imagine how much joy it gives this man to have a weekend out with a family," Fuso says, smiling. "For him, it's like winning the lotto."

Salvatore touches the boot now in Angelo's hands. "Nothing can compare with the satisfaction that comes when a desperate face suddenly smiles, or when a patient is brought back from the horror of insanity."

"When I get taken," Angelo jokes, "promise you'll do the same for me?"

"For you, anything!" Salvatore laughs.

"So, tell me about the two governors who come here," I ask.

"They are very committed, and always speak with the inmates. And they follow everything we do in here, the social workers, the guards . . . the governors even go into the kitchen to check that all is fine. Without their backing, we couldn't go on."

Angelo nods, impressed, placing the boot on a shelf. As we emerge from the atelier, we see, at the end of the long corridor, the two gentlemen following the guard out like fleeting shadows. Their visit is over.

I hear the blue-uniformed guard unlocking the big gate that creaks open, and imagine the two gentlemen walking out into the world of the sane and down the long ramp descending from the prison, past the piles of garbage and trash bags stacked beside a small, forlorn old 500 Fiat missing two wheels. I see them heading all the way down Via Toledo to the celebrated opera house, Teatro San Carlo, quite probably ending at the *Circolo dell'Unione,* or Union Club, to sit down in comfortable armchairs and savor a drink and a chat.

Over generations, the *Circolo dell'Unione* has catered to the Neapolitan aristocracy. From Palermo, Rome, Genoa, and Milan, such clubs remain bastions of "society." In Florence, the club is an oddly frugal affair on Via de' Tornabuoni, not quite up to the city's allure. But in Naples, the *Circolo* is spacious, noble, and grand. By night, operatic

music and arias from the San Carlo rise up through the aging shiny parquet floors, and by day, the view from the huge terrace, projecting out almost to touch sky and sea, takes your breath away.

I'm told that Idanna's dashing great-uncles passed many fine evenings there, dancing under the towering Venetian chandelier in the golden ballroom to jazz and boogie-woogie bands before the war, when life was gay.

Before the bombs began to fall like rain over their city, turning palazzos and streets to rubble.

Chapter 14

TOUCHED BY LIGHT

Italian has one word for sleep and another for dream. Neapolitan has just one—suonno. For us they're the same thing.

—*Erri de Lucca*, Monte di Dio

*C*aravaggio *notices a frail little boy sitting alone on the broken cobblestones. He does not beg, but stares in wonder at the world. The painter reaches down. All of a sudden the kid stands up. Surprisingly, there is nothing wrong with him. He has seen the artist walk by more than once. He doesn't look surprised when Caravaggio talks to him. A moment later, together they enter the sacred space where the painting is coming.*

"And what's he doing here?" demands the young woman posing, quickly covering her breast. "I don't want anyone to see me . . ."

"He's only a little boy, Pero," the maestro reassures her.

The boy stops, dumbfounded, his eyes scanning the enormous half-finished painting. He points, recognizing the woman on the canvas. Yes, it's her. And she is obviously feeding someone in prison. He sees an old man's face sticking out from the iron bars.

The painter sits the boy on the ground in the shadows, as he found him, and quickly fleshes out his figure in profile on the canvas. Almost

invisible to the naked eye, the scugnizzo, *the street urchin, hides almost behind the knight whose shining sword seems to rest on his high forehead, gently mingled with his curly hair.*

"Now, look toward her," the painter instructs the boy. "Not at me—at her!"

The boy obeys, supporting his chin with his hands locked together. The artist captures his contemplative gaze across at the young woman, who has reluctantly lowered her blouse to breastfeed her father. The old man sucks hungrily. Her visit will sustain him in prison one more day.

The young lad's dreamy expression is shrouded in shadow. He is swept up by her noble gesture. Her act resonates with tenderness and grace.

Only his praying hands are touched by light.

Chapter 15

The God Vesuvius

Under these skies no fools are born!
Sotto 'a chisti cieli nun nasceno 'e fessi!

—Neapolitan proverb

On a breezy summer evening, Idanna and I drive up Mount Somma, the smaller caldera of Vesuvius, also known as the "big nose." The face of the full moon shines behind the crater.

For two millennia, brooding Vesuvius has witnessed all arrivals since the first Greek settlers from Rhodes sailed into the great bay. Magnificently imposing, like a sentinel, the humpbacked volcano is also called *Buonanima* or Good Soul. Prayers are recited and offerings are given throughout the year. All know that sooner or later it will wake again. Neapolitan fatalism accepts what comes, yet the tension is inescapable.

Since AD 79, when cinder ash-clouds buried Pompeii, the mountain has erupted at regular intervals. Lured like a moth to a flame, Pliny the Elder, author of *Historia Naturalis*, lost his life on the smoking volcano. His nephew Pliny the Younger would record his eyewitness account of the eruption that shook the classical world.

When the volcano last exploded, in March 1944, American GIs watched silently in horror as a billowing incandescent plume rose into the heavens, as high as the mushroom cloud that would annihilate

Hiroshima the following year. Norman Lewis, a British writer who served with the Allied forces, describes the eruption in his classic account, *Naples '44*.

> *It was the most majestic and terrible spectacle I have ever seen. The cloud must have been 30 or 40 thousand feet high and it expanded for many miles. Periodically the crater shot snakes of red fire into the sky that flashed like lightning.*

At Villa La Pietra in Florence, a New York University volcanologist, Michael Rampino, will later confirm my worst fears. "Naples is the most endangered city in the world. We've warned the government, but they don't seem to take it very seriously. Thousands live under it. When it happens, there will be a cataclysm. The next eruption is closer than anyone thinks. No evacuation will be possible. All the roads will be jammed. No one will get out alive."

Every evening, over six hundred thousand people fall asleep on the mountain's flanks. Mothers tuck their children into bed in homes that rest on historic lava flows. Once lights go out, moonlit citrus trees droop with the bitter fruit of denial.

We finally reach the outskirts of the small town of Somma Vesuviana, high up on the slopes. Big neon lights illuminate a collection of parked cars.

"Let's try here," Idanna suggests. "Angelo said it's called Lanternina even though there's no lantern and no sign outside." I push the door and noise spills out of a brightly lit, smoke-filled tavern. We are in the right place, because we spot our friend at the wood-burning pizza oven, wearing a white apron and a white cap.

Seeing us, he bursts out, "Idannaaaaa! Terenziooo!" and waves his flour-covered arms. Comedy and song may be Neapolitan natural gifts, but don't call pizza fast food in front of Angelo. Making pizza is an art form. As a master *pizzaiolo*, his talent is in great demand. This, Idanna tells me, is his night job.

"So many people in Italy have a second job. How else do you think Italians support their families?"

I scan the crowded tables full of animated faces of extended families from kids of every size to their great-grandparents. Esposito shows off a bit, whirling the dough high in the air with lightning speed, then slapping it down on the marble counter. Fiercely proud of his craft, he tells us that the thin-crusted Roman and the deep-pan Chicago versions are heresies. He pulls a genuine Neapolitan pizza out of his wood-fire brick oven. *Pomodoro fresco*, fresh tomatoes draped over the dough with *fior di latte*, pure cow cheese, and basil sprinkled atop, then liberally doused with extra-virgin oil from Somma. Angelo insists that mozzarella—buffalo cheese—is full of water, so it's not good for pizza.

"I always keep my eye on the oven temperature. It's the most important thing. Here we eat pizza the way it should be, *marinara* or *margherita*. When I really want to be extravagant, I make the *capricciosa* and the *quattro stagioni* but that's it, the truly Neapolitan pizzas." He speaks so fast about his second life that for a moment we forget how hungry we are.

"Now guess who invented pizza?" he calls out theatrically. "My very own namesake in 1896, he was called Esposito!"

"Come on!" I protest.

"It's true. I'm telling you. One evening, the queen arrived from Rome unexpectedly. And she was hungry. In the palace, you know, the one in Piazza del Plebiscito, nothing was prepared, and so a helper in the royal kitchen improvised with the little that was there. And out came the first pizza with the three colors of the Italian flag: red, white, and green. The queen ate it with gusto and absolutely adored it! And because her name was Margherita and she was so loved by the Italians, Esposito gave it her name." He takes a bow.

He then declares his favorite day of the year, the Day of the Woman in March.

"It's fantastic," he says, "a great feast. The Lanternina is packed with grandmothers, mothers, daughters, and even at times great-grandmothers, all eating pizza together. You know, I cannot stomach those who oppress or abuse their women. A woman must be treated with white gloves or with flowers. I have my wife, my daughters, three granddaughters, and now they all insist to bring a female dog into the household. This I refused."

Kneading his dough, he muses out loud. "Caravaggio has taught me many things! It's so much better to give than to receive," he stresses. "Now when I can offer a cup of coffee to someone or give people a delicious genuine pizza, I'm a happy man. As you know, in the morning I'm at Pio Monte, at night people come from all over to eat my pizza! What more do I want, Terenzio?" He turns and comically offers his hand, New York style.

"Bravo, Angelo." I slap his palm in jest.

His jokes and our camaraderie bridge the last barrier between us. Call it lingering suspicion or wariness. The unspoken distance between our worlds has vanished. Reaching under the wooden counter, he grabs a hardcover book and carries it over to our table. "At closing time, I always look at Caravaggio," he says, pulling up a chair. He turns the pages slowly, one after the other, under our gazing eyes: *Supper at Emmaus, The Calling of St. Matthew, Penitent Magdalene, David and Goliath.*

When I ask him about working under Vesuvius, Angelo shrugs. "You know what my mother says: 'Don't worry, my son, keep laughing—the worst is yet to come!'"

Then he points to a watercolor of a flaming red erupting volcano that hangs on the wall.

"Read what's underneath and you'll understand what's coming." In the thick plume of white smoke are words written in Neapolitan dialect by a noted vernacular poet, Ezio Bruno de Felice. Angelo reads aloud as if on stage. The few remaining guests turn to listen, captivated and amused. Idanna translates:

> *I am Vesuvius gone mad.*
> *Cement houses*
> *Grip at my neck like fleas.*
> *Garbage is up to my mouth.*
> *My patience has run out.*
> *All I see disgusts me.*
>
> *For too many years I've said nothing.*
> *I am like a corpse, rotting.*

But heed my warning,
Be careful!
Get off my flanks, now!
Imagine, all of you coming
To live on my shoulders!

I am not dead, just asleep.
If I wake up, hell will break loose!
Never forget what I did
After centuries of silence,
I went wild
Like a beast.

I buried three beautiful cities,
Pompeii, Stabiae, Herculaneum,
Killing our ancestors,
Even the great Plinius.

Am I speaking to deaf ears?
Are you listening?
I will turn into a dragon and
All of you will die of fear
Even before I spit lava and fire
Burning, destroying,
Burying you all!

"See how pissed off he is?" Angelo laughs. He pours some red Lacryma Christi in my glass, literally "tears of Christ," from the volcano's grapes. "Here in Somma," he says, "they make offerings to keep him quiet."

"As they should," Idanna agrees, "just like the Balinese who pray to their volcanoes, and give them endless offerings."

"Bali?" Angelo looks puzzled.

"An island in Indonesia, where I've spent many years."

"*Tutto il mondo è paese.*" He raises his glass in a solemn gesture. "It's the same the world over."

"Yes, that's right, Angelo."

"And as long as old Vesuvius burps in the other direction, we're safe."

We click our glasses and drain them.

"I've got a surprise for you." He opens his book to the reproduction of *The Seven Acts*. "After all, you've come all this way."

Idanna and I turn our eyes to the image.

"Tell me if you see Vesuvius anywhere."

We scan the scenes. "Where?" I ask. A magnifying glass emerges magically from the guardian's pocket, and he hands it to me.

"Look, see the slope, here?"

"No . . . where?"

"Just below the angel's calf."

I lean over, peering through the lens, and then hand it to Idanna. He points at the leg of the angel.

"The silhouette of the volcano is set against his leg. And that ball of light that shapes his calf is actually the full moon."

"Yes, of course, my God!" We both see it clearly now.

"And what about this white streak below the moon?"

Yes, that too now stands out visibly.

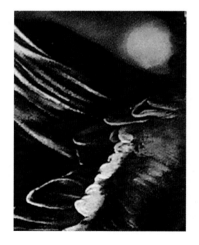

"It's the moonlight reflecting on the surf by Riviera di Chiaia, very close to where Caravaggio lived."

"The gentle waves are the angel's wing!" Idanna observes. "So beautiful! Angelo, has any art historian written about this?"

"No, I don't think so." He smiles. "But you see, for me it's easier, perhaps. The experts are all so far away. I stay for hours staring at the painting, five days a week, all year long. My eyes catch things that emerge mysteriously from the canvas. There's always something. In Naples, we live in *chiaroscuro,*" Angelo adds, "between the sun and moon, life and death. That's what I think Caravaggio found here: life's true face."

It's late. The last guests are headed for the door. But Angelo doesn't seem to be in a hurry.

"There's one more thing I've noticed. Can you see that dark column right in the center?"

What previously we had seen as a dark flat wall, on closer inspection is actually a large rounded column.

"The coat of arms of the Colonna family."

"Of course, Colonna means column," Idanna says to me.

"And you've heard of Costanza Colonna, Marchesa di Caravaggio?" Angelo asks.

"Yes, a fascinating story."

"Well, they found a thick correspondence between her and Caravaggio's aunt Margherita, the sister of his poor mother Lucia. She was the wet nurse of Costanza's children."

Angelo goes on to outline his intuitions. "I'm sure that when Lucia was dying, sometime in 1590, Costanza and his aunt were by her side. Lucia must have entrusted her gifted son to them, confiding her great worries about his quick temper and sensitive soul. Two years after Lucia's death, Costanza moved to Rome, bringing along loyal Margherita. I don't think it's a coincidence that Caravaggio arrived the same year. Right away, Costanza introduced him to his first patron, Pandolfo Pucci, the Canon of St. Peter's. But Idanna, was he any relation of yours?"

"I think so. Pandolfo is a family name, and one or two of my ancestors were cardinals. Today the Palazzo Pucci is in Vatican City."

"Oh God!" exclaims Angelo. "I'm impressed! But I hope you don't mind if I tell you that Caravaggio called him 'Monsignor Salad' because he was too stingy to give him proper food!"

"I'm sure it's true!" she says with a laugh.

"Well, Costanza was always there for Caravaggio. And her sons must have grown up with him, playing together like brothers. The 'colonna' symbol he also placed in the *Madonna del Rosario* that he painted just after the *Seven Acts*. And her nephew Don Luigi, who commissioned it, is in the painting too."

"How strange. Do you know if Caravaggio ever painted Costanza?"

"Who knows? So many paintings have been lost."

He closes the book. It's clearly time to go. We want to wait as he shuts down for the night. But he says no, it's too late, and urges us to go home. So we part ways and drive off.

* * *

Esposito padlocks the Lanternina and glances up at the moon and the grand panorama of lights that radiate all around the gulf. Driving down toward the shimmering city, only a few cars are on the road. He reaches the elevated highway that curves to the right of the urban sprawl and then rises to meet the far hills where he lives. Skirting past the financial district's high-rise buildings, he accelerates.

Finally he arrives in Miano and turns into the parking lot of his building. That's when he spots a suspicious silhouette standing at the corner, so he remains in the car waiting for something to happen. His intuition is right, because minutes later a car pulls up slowly and stops in front of the dark figure, then peels away. The pusher's sold his dope.

He steps out of his car, locks it, and walks up to his building. It is then that he sees a second person approaching the pusher on foot, and he recognizes that gait, a shuffling walk he knows only too well. Flashing headlights startle Esposito. An SUV screeches around the corner. It comes to a stop. The tinted window lowers. A pistol glistens on the dashboard lit by the street lamp. The window rolls up quickly as the engine roars.

Esposito ducks inside the entrance, his blood racing in his beating heart. It's a patrol of Camorra vigilantes. He takes a deep breath and looks back outside. The black cruiser has gone. All is quiet again.

He quickly climbs the four flights of stairs. He opens his door and closes it tightly behind him, bolting the lock. Tiptoeing in, he gives each sleeping daughter a kiss. Then he slips into his bed where Lucia is sound asleep. This may not be "*paradiso*," but it is the closest he will ever come to it.

* * *

Meanwhile, in our sumptuous cozy bedroom in Paola's home, Idanna runs her fingers across the linen sheets painstakingly woven by hand.

"Feel this soft beauty. My grandmother had sheets just like this." She sighs, thinking about that lost world of Villa Pavoncelli, so physically close to us here in Posillipo and yet so distant.

Then she asks as if speaking to herself," What have we done to deserve all this? There are thousands in the world without a roof over their heads, and we are in this divine home. Why us? In life, it's only a matter of luck how you start out . . . how can there be justice? It's pure luck if we find ourselves here, instead of in a huge building managed by the Camorra in Scampia. There, it's one in a thousand who can break out and have a life . . ."

With her Dickensian logic, Idanna has summed up a central truth of life, that the circumstances of one's birth—where and when and from whom—are not predestined, not a question of divine intervention. It's a roll of the dice.

Chapter 16

POET OF HOPE

The world is not respectable; it is mortal, tormented, confused, deluded forever; but it is shot through with beauty, with love, with glints of courage and laughter; and in these, the spirit blooms timidly, and struggles to the light amid the thorns.

—*George Santayana*, Platonism and Spiritual Life

At dawn, Angelo wakes to the aroma of coffee. Outside his window, the first morning rays light up Vesuvius's craggy nose. In the kitchen, headlines blare from the radio: "*The ex-wife of Maurizio Gucci, heir to the famous fashion house, sentenced to twenty-nine years in prison for ordering his murder by hit men . . .*"

On mornings like this, Lucia swings wide open the kitchen shutters and calls out, "*Sole, aria, salute!* Sun, air, health!" She then raises a cigarette to her lips and takes her first drag of the day. Exhaling a stream of smoke, she ends with, "*Perdono e misericordia!* Forgiveness and mercy!"

Angelo first caught sight of Lucia one afternoon many years ago, on her first day at the shoe factory where he had cut leather over the cold winter months. She walked in with the scent of waves, lemons on warm winds. Over the summer, he saw her again and again. Hiking back together from the port of Mergellina, Angelo would hold her hand and carry a basket of twisting fish fresh off the boats in his other hand. Lucia pulled him like a magnet, with her wide eyes and swaying gait. He courted her under the moon. She haunted his

dreams. He begged her to be his woman. A year would pass before she finally agreed.

For over twenty years, they've been clinging to their flat on the third floor of a battered high-rise on the periphery of the city. Over time, she has evolved into a classic Neapolitan mamma. Here they've raised their four daughters: Rita, twenty-three and married; the eighteen-year-old twins, Anna and Maria; and thirteen-year-old Chiara.

Their windows brush the low-flying clouds in Miano—one of the many towns engulfed in the endless cemented urban sprawl of Naples. When the government first assigned him this flat, he felt lucky. Subsidized rent meant he could afford the place. The postal address for the government project reads like a Kafkaesque cable with the number of the law that began the construction, the year the building was finished, the block number, the building number, the stairwell, the floor and finally the apartment number.

But slowly, Camorra families muscled their way into the building, seizing apartments right and left, even the one across the hall. The criminal organization rules the city with such an efficient stranglehold that Neapolitans call it by another name: *il Sistema*—the System.

Each morning, Lucia sets out in a bus to fashionable Vomero, where she works as a housekeeper. Angelo drives into the heart of the megalopolis. When he turns the ignition of his Lancia, he always whispers "*Grazie nonna*" to his departed grandmother who, one night, came to him in a dream. *Nonna* carefully poured him a glass of wine. He remembered the delicious taste. When he opened his eyes, he knew this was a sign. That morning, he went to the bookie and put his money on the number 45, which means "good wine" in the numerology language of Naples called *Cabala*, an Andalusian import of the esoteric thirteenth-century Jewish mystic teachings. Interpreting dreams in Naples is a big business, and the ultimate dream guide called *Smorfia* defines the characteristics of each number so you can win the lotto with help from beyond.

Sure enough, Angelo won the money he needed to buy a car and more. And so, every morning before he starts out, he thanks his *nonna* for his wheels. Because of her, he doesn't have to ride in the back of a bus and he can also drive the family to the beach in Pozzuoli.

The road descends steeply from the verdant hill of Capodimonte, curving back and forth like a nervous snake. This is Angelo's daily route into the ancient labyrinth where he was born forty-seven years ago.

Near the Duomo, he parks and padlocks the steering wheel. Minutes later, he walks into the small Piazza Sforza that is dominated by a statue of San Gennaro, the beloved patron and protector of Naples, placed high up on a marble column.

He salutes old Giovanna seated at her folding table with an array of Chesterfields and Lucky Strikes—contraband tobacco smuggled in by the Camorra from Tirana and Beirut. Giovanna's been peddling here since American troops marched into the city in 1943 with a bounty of enticing gifts, such as silk stockings, whisky, cigarettes, and chocolate for the starving population.

She bids him good morning with her gaping smile flashing three remaining teeth.

The guardian pulls a big iron key out of his pocket. Its patina is smooth as glass. He slips it into the centuries-old lock of a gate. It clicks over. He pushes. The gate groans open into the arched portico of the Pio Monte Church. His smaller key opens the wooden door. He steps inside.

Shafts of morning sun spill down from the cupola skylights into the octagonal chapel. On the marble floor, a luminous pool of light glows. His gaze turns to the painting above the main altar. This is the best time.

In silence, he takes in the scent of old wood, faded flowers, incense, and melted wax. The hush each day holds him like a pair of warm arms. In moments like this, he sometimes actually hears Caravaggio speak. It doesn't occur often. But once in a while, the silence is broken.

When this phenomenon first happened, he was not taken aback. After all, his mother always spoke with the spirits. The invisible ones, she called them, the ancestors. She taught him early on to pay attention, to listen. So he sits quietly in the front pew. And hears the voice of the master.

"*Ecco,* Angelo . . . There you are!"

* * *

A season passes before we return to the Pio Monte. Yet when we meet Angelo again, our bond has bridged any divide. Much has become familiar. But this time I notice a fire in his eye behind his smile. Something he's carrying inside that wants to get out.

A sudden downpour lashes Spaccanapoli. Windows fly open as women haul in their sheets and laundry overhead. Soon, the gray storm clouds pass and break into blue openings that cast down streams of light. Puddles of rain lie in patches of the uneven cobblestoned streets, catching the reflections above. We take shelter with Angelo in a nearby trattoria.

Idanna has arranged for Lucia and their daughter Rita to join us for lunch. But at the last minute, the guardian tells us that they will not come.

"But when will we ever get to see your family?" she asks.

"What can I do? Lucia is always busy, and Rita has three small daughters," he says, nervously apologizing, and then returns back to his favorite subject. The artist.

"They won't leave him alone!" He's clearly upset and confesses that what he has read in a new book infuriates him. "Why do they attack Caravaggio?"

He takes it personally as if a member of his family is being insulted.

"Why?" he asks again.

A pungent scent of long nights clings to the walls of the trattoria. We order our pasta and a carafe of red.

"Look at this, *Caravaggio Assassino!*" He slams a book on the table. "The author, Riccardo Bassani, writes only about his street fights, his arrests, the murder, prostitutes, boy-lovers. Then, imagine! Another art historian pops up: Monsignor Sandro Corradini, member of the Confraternity of Pio Sodalizio dei Piceni that takes care of the Holy Mary's original dwelling, preserved in the town of Loreto, a pilgrimage site on the Adriatic coast. This eminent priest is the passionate archivist of the Confraternity's vast library located in Rome. Well, guess what? He found out that most of Bassani's information is fabricated!"

"Scandal always sells . . ." I observe.

"You see what Caravaggio has to go through?"

Angelo's resentment touches a raw nerve. He's right. Never have interpretations of an artist's life been so discordant. Ferocious accusations

have been hurled at Caravaggio for years. Killer, heretic, pedophile, rebel, and so on.

John Ruskin, the celebrated English art critic, labeled him "among worshippers of the depraved." The famed French Baroque artist Nicolas Poussin declared, "he came into the world to destroy painting." John Addington Symonds, another noted English critic, sneered at his portrayals of "sacred and historical events as though they were being enacted in the ghetto by butchers and fishwives." Over time, character assassination created an open season on his name and reputation.

A spate of plays, mystery novels, articles, and films have spawned a damning tabloid portrait of Caravaggio, glorifying the violence in his life, highlighting his sexuality, looking far beyond his artistic genius. Perhaps these obsessions speak more about our contemporary culture than we'd like to think. But one thing is sure—Caravaggio now carries the stigma of *pittore maledetto,* cursed painter.

"Still, I feel so close to him. Of course I take it personally. No one is there to defend him." Angelo knocks back his glass. "Perhaps it's my hot temper. I'm also a born rebel."

"I'm on your side, Angelo . . ." Idanna tries to calm him. "So little is known about him as a person that all one can do is imagine. Nothing is sure."

Aside from payment receipts and court records, the only written testimony of Caravaggio while he was alive bears the signature of Giovanni Baglione, a mediocre painter and his most jealous rival. But how can we believe his account? Baglione sued Caravaggio for libel and, more than once, tried to have him arrested to get rid of him. His writings are charged with the same acidic spirit with which Salieri will slander Amadeus a century later in Vienna. Over time, Baglione's biography would feed generations of scholars, perpetrating a perverse myth.

Three hundred and fifty years passed before critics began to speak of Caravaggio as one of the great masters of Western painting. Only after the Second World War was the first exhibition held in Milan to shed light upon the genius that had been neglected for so long. Esposito lights a cigarette. He cannot stop thinking about the message that Caravaggio left in *The Seven Acts.*

"I've had lots of trouble myself in life, and this painting forces me to reflect. At the beginning, all I knew about Caravaggio was his face."

Reaching into his pocket, he pulls out a pastel greenish 100,000 Lira bill, a small fortune, and hands it to me. Like Lincoln's face on the $5 bill, Caravaggio's melancholy face stands out.

"But with the damn Euro, we've even lost this," Angelo laments. "I have kept this bill as a memento. If Lucia found out, she would take it to the bank at once and change it. Had he been a philosopher and not a painter, I'm sure they would have burned him at the stake as a heretic, just like . . ."

"Giordano Bruno," I finish his sentence.

"Exactly."

I recall the gray statue of Bruno, the Neapolitan mystic philosopher who stands ominously in Rome's Campo dei Fiori. In 1600, the year of the Jubilee, Bruno's condemnation by the Vatican ended with his celebrated public execution, one that young Caravaggio must have surely witnessed. As the flames engulfed Bruno, a priest put a crucifix in his grasp, but Bruno pushed it away in his last gesture.

Our steaming *spaghetti alle vongole* arrive. White baby clams simmer in garlic with sprigs of green parsley. Angelo's spectacles cloud over. He wipes them clear and then draws closer.

Then, with sadness, he pours out the tale of Caravaggio's final years after Naples.

In less than four months, on January 9, 1607, the painting is finished. The guardian believes that Donna Costanza Colonna surely must have attended the unveiling, because she was in the city at the time.

The painter leaves Naples about six months later, in summer. He sails south to Malta, as a guest of Costanza's son, Fabrizio Sforza-Colonna, commander general of the Maltese fleet of war galleys.

The island of Malta holds the fortified headquarters of the Knights of St. John. In a short time, the artist completes two stunning portraits of the grand master, Alof de Wignacourt, who rules the island with an iron fist. Caravaggio's artistic talent deeply impresses this cultivated Frenchman with lofty ambitions. Caravaggio also paints the tragic moment of *The Beheading of St. John the Baptist,* the patron saint

of the Knights. This enormous canvas still hangs in the Cathedral of St. John in La Valletta. These paintings bestow on the fugitive artist an elite honor reserved only for aristocrats. At last, the painter receives his knighthood, with all the recognition and protection he seeks, and all this with much thanks to the Colonna family.

But, after one year in Malta, another disaster befalls him when he breaches the rigid code of conduct that forbids fighting between knights. Was it a flagrant duel or yet another brawl? It remains a mystery. However, he is swiftly thrown into a dungeon and stripped of his knighthood. There will be no clemency. Again, with the help of secret allies, he escapes from the impregnable prison and leaps onto a waiting *felucca,* a small sailboat that spirits him in a night crossing to Sicily.

Again a hunted man, Caravaggio keeps moving across the island, from Syracuse to Messina and then Palermo, and always leaves a masterpiece behind. By day, he picks up his paintbrushes. At night, he falls asleep with his dagger in hand. In Syracuse, he finds his old friend Mario Minniti, who lines up a host of Sicilian nobles eager to fund his talented hand, overlooking his many transgressions.

Feeling restless and paranoid, he paints *The Burial of St. Lucy,* but leaves Syracuse before its official unveiling. In Messina, he creates *The Raising of Lazarus* and gets paid three times more than in Rome, and also *The Adoration of the Shepherds;* in Palermo, *The Nativity with St. Francis and St. Lawrence* (stolen by local Mafiosi in 1969, and not seen since).

Then, surprisingly, he surfaces in Naples again. We don't know for sure, but it's quite likely that he found his way to Palazzo Carafa-Colonna, where his "guardian angel," Donna Costanza, was staying at her nephew's palace.

"But very soon," Angelo says, "all hell breaks loose. Late one night, he gets attacked, slashed, and left for dead by thugs just outside here." I turn to look through the window where Angelo is pointing: there it is, the Cerriglio, still there after over four hundred years!

The brutal assault occurs in front of that tavern. October 24, 1609. His enemies have found him. Is it the Tomassoni family from Rome that has taken revenge for their dead brother? Or are they knights from

Malta unleashed by the merciless grand master to teach the artist a final lesson? No one will ever know.

But the painter does not die. Slowly, he is nursed back to life in the Colonna household under Donna Costanza's care. The wounds across his face will take months to heal and will leave deep scars. Meanwhile, rumors arrive from Rome. Pope Paul V may grant him a pardon.

This wondrous change of fortune inspires him to pick up his brushes in spite of his frailty. He cannot stand up alone, and arranges to be lifted and kept on his feet by a mechanical device called *scafato,* used by dockworkers for repairing the sides of marine vessels. In this way, with his eyesight impaired and hardly able to hold the brush, he works feverishly on *David with the Head of Goliath,* a chilling painting that he will send as a gift to Pope Paul V from the Borghese family through the intermediary of the pope's young nephew, Cardinal Scipione Borghese, a voracious art collector.

The Italian Nobel Laureate of literature, Dario Fo, suggests that this extraordinary painting represents the artist's double self-portrait. David is Caravaggio as an adolescent boy. And the giant Goliath is also himself—aged, desperate, and scarred. According to Dario Fo, a letter was found behind the painting, addressed by Caravaggio to Paul V. It reads:

> *I send you this painting. It is I as I am now. You can see here the pain and anguish for my crime, for which I desperately repent. The remorse for the murder I committed has destroyed me, and you can see it on my face. Holy Father, if you wish to save me, please pardon me, otherwise I will be like this head, suspended in darkness. In this painting, I also send you Caravaggino and it is he, young, innocent, and pure who offers you my life.*

The artist consigns the painting to a courier bound for Rome, so the Pontiff may receive it as soon as possible. Then he packs his other artworks and prepares to sail north and return to the eternal city, but only once the clemency is granted.

Esposito continues the story with a heavy heart. "Months had passed from the attack and he was still sick when he left my city. If he had only stayed . . ."

In July 1610, when the artist boards a boat bound for Porto Ercole on the Tuscan coast, he carries with him three paintings as a gift for Cardinal Borghese, the art collector, who has lobbied with his uncle to lift the death sentence. The boat anchors first at the tiny port of Palo Laziale near Ostia, where Caravaggio has decided to wait for the news of his pardon before setting out overland to Rome.

But in yet another strange turn of events, he is immediately taken into custody by the captain of the garrison, before he can unload his possessions. Is it a case of mistaken identity or a problem with the artist's letter of passage? All we know is that once he's freed, the artist discovers that the boat has sailed off with his precious cargo, destined as a gift for his Vatican savior. Caravaggio has no choice but try to catch the boat at the next port, Porto Ercole. Even though he is weak, he sets out by foot, over land, in the blazing summer heat.

"That's when he disappears," sums up Angelo. "It's a mystery. He was only thirty-eight. They say he died on the eighteenth of July, three days before the pope placed his seal on the pardon. His body was never found." He pauses. I fill his glass, and he empties it with one gulp. "Who was there for him?"

Then he turns to me.

"All I want is to clear his name!" he confesses in a hushed tone. "*Capito?* You understand?"

* * *

A sliver of a new moon hangs over Vesuvius. Warm winds from the Libyan Sahara have left rust-colored desert dust on the balconies of Posillipo. But tonight there is no breeze. The air is still. I listen to the refrain of soft lapping waves, feeling restless as Idanna sleeps. Esposito's words about Caravaggio's curse haunt me.

The guardian has grown strangely more on edge, as if a sharp knife is rubbing against his shoulder blades. He talks about many things and

seems to put all his worries in one big basket: the uncertainty of his daughters' future; his apprehension of being moved to another church; the shadows of the Camorra that corrode his world in Miano. But mostly, he dwells on how Caravaggio is portrayed and his tragic end.

He doesn't understand how art scholars who have never known hunger, never had to seek shelter, never been jailed or pursued by violent thugs, can make such harsh judgments on the artist's character and life.

All their vile gossip stirs our friend's blood. He cannot bear it and wants to protect "his maestro" from tabloid history. He feels in his heart that few understand, because few are able to feel his message of compassion.

"Why can't they see him as a poet of hope?" he implores, speaking now like a poet himself.

Chapter 17

SAMSON'S ROAR

Everything that happens, including humiliations, embarrassments, misfortunes, all has been given like clay, like material for one's art. One must accept it . . . Those things are given to us to transform, so that we may make from the miserable circumstances of our lives things that are eternal.

—*Jorge Luis Borges* (on his blindness)

*C*aravaggio breathes heavily as he reads a letter he has just received. News from Rome is grim. The pope still denies clemency. The Tomassoni clan demands his blood. Assassins are sharpening knives. Their vendetta will not rest until they have his head. They may be already in Naples.

The artist folds the news, puts it into his pocket, and slips three silver coins into the courier's hand. The rider bows and, in a flash, he slides into his saddle with the grace of a cat. The skittish horse rears its sweating neck and passes under the looming arch, leaving behind the echo of its iron-soled hooves on the cobblestones.

At that same moment, in Rome, young Cardinal Scipione Borghese is reading a coded message forwarded to him by the office of the Inquisition. It carries news of Caravaggio. The artist, whose work he covets, now is living in Naples, a free man. He is being feted by nobility who speak proudly of his talent and boast of the prestige his work shall bring to their kingdom. A guest in the Palazzo Carafa-Colonna, he has been honored with his first commission—an altarpiece for the Pio Monte della Misericordia.

The cardinal plucks a loose silk thread from his pearl-studded lace cuff and toys with it. He adjusts his ermine cloak before sipping from his glass of reserve Montalcino. The hunt has begun. The Vatican's network of spies will keep him informed. He must set the bait to lure the artist back to Rome. He must track his every step.

As night falls, Caravaggio tries to close his eyes but can only lie awake in bed. He hears voices around him: the Philistines who mocked him in Rome; those who cannot see his light; those who cannot understand the message embedded in his work; those who attack and persecute him.

Restless, he throws off his blanket and lights a candle. He opens his copy of Aurea Legenda, *printed in Venice. This medieval bestseller,* The Golden Legend, *by Jacobus de Voragine, is a rich collection of narratives on prophets, heroes, and saints. Caravaggio reads of the Israelite who stood alone against thousands. Alone, with his bare hands, Samson turned back the enemy. Alone, he fought and left the battlefield littered with bodies.*

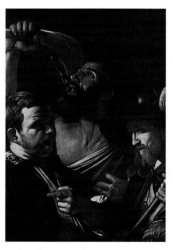

The maestro closes the book. The candlelight flickers, casting his shadow on the wall. He now understands what he must do. There will be no violence in this painting.

He will stand his ground, letting God fill the jawbone of an ass with water to quench his thirst. He will cleanse the spilled blood of Ranuccio Tomassoni. He will wash away the madness. He will purify his sin and seek redemption. He will perform one of the acts—water to the thirsty.

He knows that Naples has given him new life. Even though fear is always at his side, he is a free man nonetheless. The seven founders of Pio Monte have befriended him with their trust. For that, he is grateful.

Here, honor killings are understood. When a woman is violated, the abuser must die. This is what happened with Tomassoni. The thug had abused young Fillide, and Caravaggio tried to avenge her.

Here, no one mentions the murder, they know better. His hand crumples the letter from Rome. He stares into the mirror at his shaggy beard and

*the scar that marks him. His face
has seen battle. He blows out the
candle and throws himself back
onto the mattress.*

*Tomorrow he will need no
model.*

He shall simply use the mirror.
He will shake the temple.
He shall be Samson.

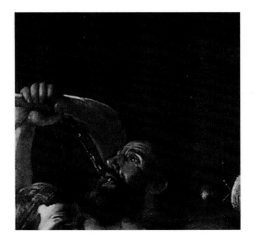

Chapter 18

Honor and Vendetta

The dawn is breaking on a new world, a jungle world in which the lean spirits roam with sharp claws.

—*Henry Miller*, Tropic of Cancer

From Florence, we call Angelo a number of times, only to find his phone disconnected. Like all those who live in the projects, he doesn't have a fixed phone, only a mobile. It's easier to control and cheaper to use. His daughter Rita doesn't answer either. For two months we've had no news. It feels strange. Idanna has a sense of foreboding. We've had no contact at all. He's simply vanished. And the last time we saw him he was truly tormented, as if a great weight were bearing down on his shoulders. I tell Idanna that I need to consult the library at the Orientale and speak to Professor Rossi again. So it is decided we will return.

An unusually cold October wind blows in rough gusts through the city. The sun has stopped shining. The great bay churns restlessly. Reaching the church, we are startled to find a new guardian. He blurts out that he has no idea where Angelo is now. We learn from old Giovanna, still hoarding her cigarettes, that the guardians have been rotated. It was long overdue. But she doesn't know to which church they have assigned him.

"One day he was gone," she says, offering me a smoke.

We search his old haunts, deep in Spaccanapoli and Forcella, and then circle back to Giannino's bar. No sighting. Our friend has disappeared. Bewildered, Idanna continues her pursuit, checking churches along Via dei Tribunali while I head over to the Orientale for my appointment.

Professor Rossi greets me with eager questions about my book. "Well, make yourself at home," he says sympathetically. "You know your way around. Next week, I'll be leaving for Shiraz!" He smiles broadly.

Later that evening, at Paola's home, we recount our concerns about Esposito to her over dinner. Her reaction is very cool.

"Don't get involved. You don't understand his world. Not all Neapolitans are reliable."

Idanna and I protest, describing his insights and generosity of spirit. But Paola dismisses our words, calling us naive. Although she has been impressed by Esposito's understanding of the painting, all she can say now is, "Be careful. You don't know what's behind it."

The next morning, we follow our instincts back to Spaccanapoli. Idanna continues seeking Angelo while I return to the Orientale. Around midday, in the heavy silence of the library, a text message flashes on my cell: "Found him. Come quickly. At the Girolamini."

I run down the stairs and sprint over to the second largest church in the historic center. Its ivory white façade shimmers in the fleeting sunlight. I rush inside and stop before a dark forest of scaffolding and rigging that blocks all light in the freezing cavernous interior. Rubble litters the floor.

"He can't be in here," I say to myself. "Idanna! Where are you?" I call out.

No reply. Silence. Then I hear her familiar voice. I turn around, stumbling over a fallen wooden plank.

"Over here! Come!"

"Idanna!"

It is then that I see her silhouette next to a small figure crouched on a chair in the shadows. It's Angelo. Thin and ashen-faced, our friend has aged; his hair's gone gray. He stares up with empty glazed eyes.

Idanna tries to shake him.

"Angelo, I can't believe that being separated from the Caravaggio has reduced you like this," she says. "It's just two streets away. You can go there whenever you want . . ."

"You don't understand," he interrupts her.

"I can speak to the office of Pio Monte," she insists.

"I'm not their employee. The City has moved me."

"I can try . . ."

"Don't," he replies feebly. "*Sono maledetto.* I'm cursed."

"Why do you say that?"

"First I lose the Caravaggio and then . . ."

"What happened?"

On the verge of tears, he begins his confession. At first his mumblings are incomprehensible, but then it all becomes clear when he utters the painful words.

"*Lucia mi ha tradito.* Lucia has betrayed me."

"What?" Idanna reacts. "No!"

He slowly pours out his soul. Lucia has broken his heart. He had to throw her out of the house. It happened in front of the family, just after we left in August.

"I'm finished," he moans.

Angelo trembles in the cold, coughing. We lift him up and shuffle him out into a nearby bar to warm up.

"But where's Lucia now?" Idanna inquires.

"She's gone with him . . ."

We let Angelo talk.

"It's all my doing, I let the son-of-a-bitch stay with us . . . when my sister passed away years ago, I let him stay with us for a while. One thing led to another." His voice trembles as he stares at the ground.

"And Lucia is with him now?"

"Yes." He nervously lights a cigarette.

"So you're now at home with your daughters?" Idanna asks, wanting to know his situation.

"Yes, but my youngest accuses me and insults me. The twins ignore me." He takes a drag of his smoke. "Every day, when I'm gone, Lucia comes over to clean and cook for the girls. It's torture."

When he's laid out his tragedy, he ends with, "I'm finished."

"Angelo, what can we do to help?" Idanna asks.

"Nothing . . . nothing."

"We've got to get you out of this work site of a church," Idanna says.

He looks at his watch and stubs out his smoke. "I have to go, Idanna. It's closing time, and I have to get back home."

I reach down and lift him by his shoulders. Slowly we shuffle outside. The mournful gray skies above the city weigh on us with each step. Arm in arm, we stumble down Via dei Tribunali, making our way to his car. I measure each of his steps.

Once he gets into his Lancia and turns on the ignition, Idanna bends down with her head toward him so he can hear her.

"My friend . . . I can talk to your girls, if you wish."

"No, it's too late," he says.

With that, he drives off to Maiano, which now seems like a continent away. Idanna turns to me with beseeching eyes. I'm at a loss for words. But her antenna has picked up what I cannot. Her Neapolitan blood is down to earth, closer to the events at hand. I am sad and absentminded until she utters words that stops me cold.

"He may do something insane . . ." I know what this means. I also know that she's right.

* * *

A me? Non m'inganni: il mio esofago non tracanna in grosso!
Me? I can't be deceived: my throat doesn't swallow things whole!

—Neapolitan saying

When extramarital affairs take place in Manhattan, people usually shrug their shoulders, pick up the phone, and call their lawyers. Divorce proceedings begin. Custody battles rage over the children. Property divisions take place. In the end, life goes on. But in Naples, adultery sets off dangerous and incendiary sparks. Betrayal opens a Pandora's box of fireworks, and flames can quickly spread, leaving fatal consequences.

Over centuries, revenge has been woven into the genetic makeup of southern Italians as the prime mechanism for "saving face." When a family's honor hangs suspended in the defamatory winds of public opinion and wagging tongues, the only way to silence the slander is to take a life. Debts of honor are paid in blood. Forgiveness is not part of anyone's vocabulary. Vendettas are as natural as the rising sun. Vengeance is a low-hanging ripe fruit waiting to be plucked.

The Sicilian writer, Leonardo Sciascia, describes the forces at work in the southern mind. An eternally vanquished, oppressed people with obscure pride, people who look at the law and at all its instruments with contempt. Embedded in their psyche "is a conviction that the highest right and truest justice, if one really cares about it, if one is not prepared to entrust its execution to fate or God, can only come from the barrels of a gun."

Angelo's world, once full of small victories—free from the Camorra's grip, four lovely daughters educated with principles in spite of the snake pit of Piscinola, his surprising illumination through art—now lies shattered on the ground like glass shards strewn in tiny pieces around him.

The *Seven Acts of Mercy,* once so close to his heart, lie crushed under the weight of Old Testament logic: "eye for an eye." Just as Caravaggio dueled in Rome over the courtesan Fillide and left his rival dead, Angelo Esposito now has a score to settle.

* * *

The next day we stand with heavy hearts in front of the Girolamini, waiting. Overcast gray skies reflect our somber mood. Angelo arrives, shaken and gaunt. Nervously, he takes out a cigarette and flicks his lighter. Then he tells us how it all broke down.

"After all the help I gave him," he says, cursing, "I should have let him die in the gutter with his drugs years ago . . ."

It seems that after the funeral of his sister, her husband Gigi was alone, nowhere to go. So Angelo threw away all his syringes and pills and put him through rehab before taking him in. The girls liked having

their uncle around. Angelo worked harder at the pizzeria to feed that extra mouth. All this happened ten years ago.

Such tragedies thrive on unintended twists of fate. Over time, Lucia's mothering attention gave Gigi self-confidence and, as he recovered, she became the target of his affection. Lucia slowly fell into his trap.

The girls noticed when their mother's eyes locked in contact with their uncle, but they said nothing. Lucia was Angelo's rock of Gibraltar. Always above suspicion. In the end, everyone knew except him.

The point of no return came long after Gigi moved out. Lucia began to stay out longer and more often. One early afternoon, Angelo woke up from his siesta, ready to leave for the pizzeria. Lucia was still out, but she had forgotten her mobile in the kitchen, and it was ringing. He picked it up.

"O Gigi?" a female voice called out. He recognized the voice. It was Gigi's high-strung mother.

"No, *cara*, it's me, Angelo," he said. "He's not here," he added sharply. A long creeping doubt, now become a certainty.

Breaking into a cold sweat, he realized suddenly that Gigi's mother was looking for her son on Lucia's phone. He hung up, his hand shaking with anger. He first called his boss at the Lanternina and said he was sick and couldn't go to work that evening. Then he called all of Gigi's close relatives, one by one, as well as Lucia's mother, her sister, then his own mother, his older brother, and his daughter Rita and her husband Enzo. He invited everyone to come that very evening to his house. He insisted they should be punctual at 7:00 p.m.

When Lucia returned home from work, she opened the door and found everyone seated around the kitchen table talking loudly with high tension.

All eyes turned toward her.

"Why . . . ?" she mumbled, utterly astonished.

"You forgot this today." Angelo stood up, slamming her mobile on the table.

"I know . . ."

"Guess who called?!"

Her face went white.

"She called! His mother!" roared Angelo, pointing at Gigi's mother sitting there, her mouth shut.

"And guess what? She wanted to speak with her son, in my house, on my wife's phone . . . !"

"No. It's a mistake!" Lucia pleaded in panic.

"*Basta!*" he bellowed, "I'm the last one to know! ALL OF YOU have played the game, not just my own wife!"

Everyone erupted hysterically, filling the kitchen with cacophony.

"How could *you?*" Angelo screamed, pushing Lucia toward the door. "Get out! Now!"

Lucia's mother burst into tears.

"Out of my house! Go!"

In complete pandemonium, Lucia's sister yelled, "*Vieni!* Come!" and rushed to her. Angelo was held back by his brother. Gigi's mother ran out and down the stairs, followed by both her daughters.

"Never come back!" Angelo slammed the table. "Never!"

Rita then approached her father and managed to hug him, tears in her eyes.

"*Lo ammazzo.* I'll kill him!" howled Angelo, shaking his clenched fist to the sky.

Chapter 19

THE COMEDY IS OVER

This is a land where a man's left hand cannot trust the right hand.
 —*Leonardo Sciascia*, The Wine-Dark Sea

The night lays its long veil on buildings, faces, streets, and piazzas with its powerful ocean of solitude and sleep. We rock in the waves of suspended hours. Dawn rises over the jumbled rooftops when constellations retreat. Looking out over the bay, I think of the guardian's family disintegrating, his three girls drifting in the wreckage like fragile rafts on high seas.

The next morning, feeling a bit depressed, Idanna and I find ourselves pulled back toward the Pio Monte Church. When we arrive, a big surprise awaits us: the former guardian had our same idea. He's astonished as we are; and even relieved to see us. He tells us he called in sick to take the day off.

As we have done so many times in the past, we sit in front of the Caravaggio. His mood has changed from desperate to resolute and firm. He lists in one breath the options that lay before him, and he shares them with cold, rational logic.

"Terenzio, I've got three choices." He ticks them off one by one. "I kill him. Or I kill myself. Or I go to America."

I know that he's capable of any of the three.

Idanna lets his words disperse in the air.

"We must steal you away for a while," she says to him. "Come up to Florence with us." Angelo does not react. He just sits like a stone,

staring at the painting. His colleague also seems lost in thought in his chair near the door.

"Come on Angelo, let's go out and sit down with a coffee, make a plan," Idanna urges, rising from the pew.

But this time, we don't go to the usual bar. I hail a cab and we head to Monte di Dio, a quarter adored by Neapolitans and all tourists. I have always believed in the healing effects of beauty on the human soul, especially when torment clings.

Soon, there we stand, all three peering at the panorama from east to west across the harbor dotted with boats, steamers, cruise liners, and hydrofoils commuting to Ischia and Capri. Farther down, lines of container ships unload cheap goods from China like clockwork, eluding custom inspections with payoffs from Camorra partners. Naples has become Europe's gateway for illegal fakes and criminal contraband. Everything and nothing has changed since Caravaggio's day.

My heart thumps as horns blow. We can see passengers on the deck of a white cruise liner looking at the magic city from the sea. Multicolored flags flap in the wind. Hands wave. Swooping gulls dive acrobatically for fish. I look at the port, so pulsing with life, and it takes only a few minutes before darker images nudge from an earlier century. Those huge ships that sailed west to the New World, taking away so many to strange sounding places—Buenos Aires, Caracas, Boston, Valparaiso, Mulberry Street. These waters have witnessed so many farewells. Emigration has always been the curse of Naples. I think of Angelo's third option—America.

I feel a deep ache in my Irish blood. Memories of exile flood back when I think of my grandparents, who left Donegal as young teens. Both would die far from Ireland's wild rocky coast, so poetically rendered by J. M. Synge in his *Playboy of the Western World* and *Riders to the Sea*. Their dream had always been to return to Eire and have their final rest in the small cemetery overlooking the salt bay at Kincasslagh, a small Gaeltecht seaside village. A few miles away, the vocalist Enya would sing her first notes. My grandparents had rolled the dice and left their relatives, home, and ancestors. Each stepped ashore with a broken heart, leaving all they loved behind. They were young, found

each other, and carved out a new life in a new land. This has always been the struggle—finding grace in exile.

Now I watch Angelo stare out to sea, knowing that if he leaves Naples, he will be lost. At forty-seven, what can he hope to find over there? I recall the ever-popular emigrant song, "Lacreme Napulitane." This 1925 tearjerker, "Neapolitan Tears" by Mario Merola, is a Christmas letter from America written by a son to his mamma. He laments the pain of being far from home and the sky of Napoli. "*What is money?*" he sings.

> *For those mourning their homeland, money is nothing.*
> *Now that I have many dollars, I feel poorer than ever.*
> *This America is costing us many tears.*

The song ends with the refrain: "*How bitter this bread.*" I realize that if this is one of Angelo's options, he's in deep trouble.

* * *

Amidst Angelo's unfolding drama, Paola grows increasingly skittish. She keeps cautioning us over and over to keep our distance from the guardian. She's fearful we are getting pulled in. Now she's become testy with Idanna. "You must be careful, you have no idea what can happen . . ." she repeats to us firmly. Her Neapolitan sixth sense feels what we cannot. "You never know."

During afternoon tea, she hands me an envelope with opera tickets. I thank her for the gift: two seats for this evening at the legendary Teatro San Carlo, the oldest and perhaps the most magnificent opera house in the world.

Two centuries ago, the writer Stendhal entered this theater and scribbled in his diary:

> *I was transported to the palace of some oriental emperor . . .*
> *my eyes were dazzled, my soul enraptured. There is nothing*
> *in the whole of Europe to compare with it . . .*

During the opera season, bewitching plots of gods and lovers, fools and kings, barbers and musicians, rebels and courtesans, all parade across the stage. For generations, comedy, passion, and intrigue have been staples for Neapolitans: the humor of Mozart's *Così fan tutte*, the sinister grandeur of Boris Godunov, the pathos of Puccini's *La Boheme*. Tonight it's Ruggero Leoncavallo's *Pagliacci,* The Clowns.

As the sun is setting behind the sea, we are already walking down from Posillipo to reach Piazza del Plebiscito on time. It's a long walk, but the colors of the buildings at that hour, on a clear evening bathed in the aftermath of the disappearing sun, are the ideal initiation to what awaits us. Once in the piazza, I glance up to the lights of the *Circolo dell'Unione,* adjacent to the theater. I spot a few figures on the veranda, drinks in hand, peering out at the glow of the skies in the vast panorama of the fast-approaching night.

"Even Neapolitans cannot get used to this beauty!" Idanna says, holding herself tightly to me. "Can we call this pure happiness? I mean, such moments?" she asks, as we pass under the grand portico of the San Carlo and enter. The lights inside the "dazzling palace" are already dimming, and quickly we slide into our seats. The orchestra ends its final tuning. A hush falls over the audience. The conductor takes his place on the podium and taps his baton. Leoncavallo's opening bars hint right away at the tragedy about to unfold.

The burgundy velvet curtain parts to reveal a troupe of *commedia dell'arte* actors arriving on colorful carts in a Calabrian village square. Nedda and her husband Canio wave to the cheering crowd. He calls out to the villagers, announcing the coming performance.

"Tonight there will be a great show! The clown will get his revenge. Lots of intrigue will thicken the plot. Don't miss it!"

As the troupe unpacks to set up for the performance, Canio unexpectedly spots, from a distance, his Nedda in the arms of a young man. He roars at them, and the lover leaps over a wall. Canio chases after him in vain and returns in a desperate rage.

"Tell me his name!" he thunders at Nedda, drawing a knife, but she refuses to speak. At that moment, an actor grabs Canio's arm. "Stop! The audience is coming. It's time for the show!"

Overcome by the discovery of his wife's betrayal, brokenhearted Canio can barely put on his costume. Powdering his face white, he stares into an imaginary mirror and sings to himself:

To act! While I'm gripped by frenzy, I no longer know what I'm doing!
And yet you must force yourself!
Bah, are you a man? No, you are a clown!
The audience pays and wants to laugh.
Turn into jest your anguish . . .
Laugh Pagliaccio at your broken love.
Laugh at the pain which poisons your heart!

In tears, he runs off stage. The curtain closes. The second act opens with a group of villagers eagerly watching the show. The players take the stage: Canio as the clown, lovely Nedda as Columbine, and her suitor, Harlequin. But things go terribly wrong when Harlequin begins flirting with Columbine in front of the clown. Blinded by her betrayal in real life, Canio departs from the script. Drawing a knife in rage, he grabs Columbine.

"Tell me his name!" he shouts. The villagers gasp.

Seeing Nedda in peril, her lover leaps onto the stage. Too late. Canio has already stabbed his wife, who falls to the ground. He then mortally wounds his rival. Men and women rush to subdue the clown, who lets his knife fall and numbly turns to the audience of the San Carlo.

"*La commedia è finita!* The comedy is over!"

Silently riding home in a cab, Idanna and I feel that we have witnessed a preview of what lies ahead. Paola has given us another warning. Our hearts are heavy. We must return to Florence tomorrow on the evening train. But how can we leave Esposito?

Chapter 20

BEYOND THE THRESHOLD

There is a land of the living and a land of the dead and the bridge is love, the only survival, the only meaning.
—Thornton Wilder, The Bridge Over San Luis Rey

Death stares Caravaggio in the face each day. Famine grips Naples. For some, the end comes quickly. He has seen corpses carried out of hovels or lifted off cobblestones. In the early mornings, the carts roll down the streets to collect the bodies. This line of work is straightforward for the becchino, *the gravediggers. You see a corpse, you lift it onto the cart, and you trudge along and pick up the next one.*

The painter slips a silver coin into the palm of a military guard who lets him pass. He then climbs up the stairwell of the Porta San Gennaro, a grand gate of entry into Naples. Once atop, he overlooks the city walls. In the distance, he can see the vast paupers' grave. He covers his nose in the crook of his arm as he stares at the open pit of the Sanità. The wind is blowing south and the stench is foul. When the nameless poor perish inside the city, this huge hole awaits them. He watches a small cart approach the unspeakable pit. A corpse's feet stick out the back. No priest is in sight. Caravaggio turns away. He has seen enough.

He descends back down the stairs, saluting the guard, and then turns to walk over to the Hospital of the Incurables, where his seven patrons offer their food and comfort the sick.

Outside the hospital, a small crowd lingers in the fresh air. Inside the long halls, he passes beds of patients waiting to die. Their loved ones whimper in rags with quiet voices and tears. He stops. Before him stands a tall deacon holding a lamp. On a stretcher, a young man lies motionless. Unlike the others, this one has no one who mourns his departure. The priest brings the lamp closer. His mouth opens in prayer. Caravaggio will remember this moment.

When the seven founders first brought comfort to the dying, they noticed the absence of priests. Normally, last rites were given only to the wealthy or those personally known by the clergy. Unnerved by this injustice, the founders changed the status quo.

In the New Testament, the acts of mercy are only six. Christ could not have imagined that human beings would ever abandon their dead. There is no mention of "respectful burial" in Matthew. The founders and the artist agree. It must be in the painting. He will add this seventh act.

Caravaggio leaves the hospital and weaves his way back to Pio Monte, where he finds three models waiting. He ushers them inside.

"Come over here." He points to a barefoot fellow. "Please, lie on this table. Let your feet hang over the edge."

The fellow stretches out on his back. His bare feet extend, as requested. The painter covers his body with a white cloth. Then he calls on the other model, short with a stocky build, and tells him to hold up the feet.

Finally, the maestro turns to the tallest model and hands him a long white linen garment. "Please wear this." He then lights a torch from a burning lamp and gives it to him. The pitch flares bright.

"Good. Hold it high over the body on the table. You have become now a 'man of God.' Look down. Imagine he's your dearest brother. Dead."

Caravaggio leaves the three in pose and rushes to his canvas. Taking one last look at the group, he barks at the pallbearer holding the legs. "Lean back so I can see your face . . . yes, like that."

And with his eyes blazing, he dips his brush into the oils.

He will paint the corpse's feet with a warm tone. Death has arrived only moments ago. The face we will not see. Identity is not revealed. This human being could be any one of us. The priest performs the last rites in full public view, chanting a prayer. It will lie at the heart of his message. No matter how terrible your life may have been, you deserve this rite.

This radical image will burn at the center of the painting. All the acts of mercy will rotate around it.

The burning flame marks the immovable spot, like the position of the Buddha under the bodhi *tree when enlightenment comes. That fixed spot. Beyond all fear and desire.*

The threshold to the waiting mystery.

Chapter 21

A Dream and a Promise

One should say before sleeping:
'I have lived many lives.
I have been a slave and a prince.
Many of the beloved have sat upon my knees
And I have sat upon the knees of many a beloved.
Everything that has been shall be again.'
—*W. B. Yeats*, The Way of Wisdom

High above the age-stained entrance of the Pio Monte Church, a Latin inscription reads *Omnes Gentes Fluent,* All People Welcome. To the left, a lofty, imposing archway leads into the courtyard of a seventeenth-century palazzo, also in bad need of restoration. For this special mission, Idanna must go alone. I wait with the Caravaggio while she climbs the grand marble staircase. On the second floor, she stops before a massive chestnut door and rings the bell once, twice, three times.

She waits. Then she hears some shuffling steps. The door opens and a chubby little man peers out lazily.

"Prego, signora." He motions with a tired gesture. She enters a large Baroque hall with high ceilings and sits down in a faded scarlet satin chair with wooden arms. The man disappears. She remains there, staring at walls lined with Neapolitan paintings from the *Seicento,* the

seventeenth century. Like so many historic institutions in Italy, the Pio Monte is a hermetic world. Like a shell hiding a great pearl.

But suddenly a dynamic, tall, suave gentleman strides across the parlor to greet her. Count Gianpaolo Leonetti di Santo Janni kisses her hand in traditional fashion. He politely asks her if she is from the Pucci family of Florence. When she says yes, his eyes register knowingly. He then walks her through the halls, proudly explaining the history, and leads her into a special room dominated by the seventeenth-century heptagonal table in the center of it. Delicately crafted in walnut and ivory, the table is divided into seven triangles that radiate from the middle, each devoted to one of the seven acts of mercy and inscribed with inlaid mother-of-pearl.

"This table has a long story. One generation of governors after another used to gather around it on Fridays after the early morning mass in the church," Leonetti says. "Each of the seven would sit at the place corresponding to his particular task of work . . ." His hand touches the words *visitar i carcerati*, visiting the prisoners. "Today, we meet around a big round table, always on Friday," he adds. "It's exactly the same idea, but now there is also a place for the treasurer."

"I've heard that traditionally a few governors descend from the original founders," Idanna says. "I met with your predecessor some weeks ago, Marchese Sersale."

Leonetti smiles. "In his case, yes. His direct ancestor presided over the commission to Caravaggio. And anyway, as you well know, all Neapolitan aristocracy is somehow related.

"My father also served as president. He was so respected that when I returned from many years living abroad in the US and northern Italy, our members requested that I follow in his footsteps. I hesitated because it's a lot of work—there are currently 250 members and several responsibilities—but then I simply couldn't refuse the honor, and now here I am."

Count Leonetti does not fit the mold of the insulated aristocrat tied to the past or stuck in his palace. He's a striking anomaly, a "citizen of the world." After graduating from Harvard, his engineering career transported him across the globe from Cambridge to Milan. His

English is fluent. His cosmopolitan vision is future-oriented. He defies all Idanna's expectations.

"I intend to bring Pio Monte into the twenty-first century," he announces. His idealism contrasts with the overall feeling of ages passing and nothing changing.

"You have a long way to go, and so much to do then!" Idanna responds. "Where do you begin?"

"With the archives," he replies candidly. "You know, all our documents are piled up in a dusty storeroom: the original contract signed by Caravaggio in 1606, as well as the statute document composed and signed by our founders that forbids the painting from being moved.

"Actually, the painting was taken down and hidden in safety during the war, once the first bombs began to fall on Naples. Since then, it has left twice, once to the nearby Royal Palace, and in 1965 to the Louvre, its only trip abroad. Loan requests arrive often, even from the Metropolitan Museum in New York, but we hardly ever accept. Whoever wants to see it, must come here."

"What a great rule," says Idanna. "Just like the *Madonna del Parto,* the Birthing Madonna, by Piero della Francesca in Tuscany. Without it, even for just a brief moment, the village of Monterchi would lose its soul, its identity." She is not quite sure how Count Leonetti will react to these words.

"I agree with you," he says in a firm tone. "This special rule elevates a unique work of art to another level and increases people's curiosity. It gives a crucial message: money cannot buy everything."

At this point, Idanna feels confident that she can approach the subject that has brought her there today.

"May I ask if you've ever met the guardian downstairs in the church?"

"Which one?" the count asks.

"The one called Angelo Esposito."

"The thin one with glasses?"

"Yes, that's him."

"I haven't seen him in a while. But then, you know, we go there only once a week for mass. Why?"

"Have you ever listened to him explain the painting?"

"No, I haven't. You know, the city has placed these guards here for security, and we've got little to do with them."

Feeling at ease, Idanna begins quickly to express her admiration for Angelo and his attachment to the painting.

"Many visitors must have been inspired by his narration . . . just as it has happened to us."

The count listens with interest and surprise.

"Next time, I'll be sure to say hello to him."

"But you can't, because he has been transferred to another church. Which is a real pity. Could you try to get him back?" she asks bluntly.

"Unfortunately, we can't tell the city what to do with their employees."

"But can't they make an exception? With your plans for the future, you'll need someone like him at least for a while . . ."

Count Leonetti looks Idanna squarely in the eyes. Seemingly amused by her insistence, his voice changes. His tone deepens with gravitas.

"Our founders broke all conventions when they joined forces. Caravaggio did as well. If Esposito explains our mission as you have said, he belongs in our church. I will try my best," he assures her.

"Thank you," she says, with a big, warm smile.

Count Leonetti then begins to outline the Pio Monte's ongoing humanitarian commitments—the orphanage for abused children on the island of Ischia; a kindergarten for children from immigrant families in Bacoli; a home for the elderly on the hill of Capodimonte; the juvenile detention center in Nisida; and the notorious prison of Sant' Efremo. Across Spaccanapoli, a host of apartment buildings bequeathed by wealthy Neapolitans shelter the needy at the lowest of symbolic rents. In the Pio Monte's inner courtyard, a medical dispensary opens its doors to patients daily.

"We also recently shipped food and blankets to Kosovo," he adds, before sharing his ambitious plans for the new millennium. These include the restoration of their entire rare collection of paintings from the 1600s that now hang like forgotten icons in the halls; computerizing the centuries-old archives and setting up a website system that will

allow scholars from all over the world to consult precious documents never seen before; and, eventually, the restoration of the entire palazzo in time for Pio Monte's 400th anniversary.

Walking through the hallways, Idanna feels that Leonetti's vision is light-years away from the centuries-old fatalistic inertia that weighs down the whole of Spaccanapoli as it does the world of Lampedusa's Prince of Salina, known as the "Sicilian Leopard."

"Our historical and spiritual assets have survived everything, even the aerial bombings." Leonetti's confident voice exudes a hope for change. He is determined to awaken the humanitarian institution from its lethargy. The words of this true aristocrat already seem to brush away a heavy veil of dust and decay.

"In this city, rich and poor share the same passions, the same tragedies," he says solemnly, escorting Idanna to the door. "Remember that Naples, the Pio Monte, and Caravaggio are one."

"Your dream will come true, I'm sure," Idanna says, "and we will be back to see it."

At the door, the worldly gentleman kisses her hand. "So pleased to have met you. I'll do my best for the guardian. It's a good idea."

* * *

> *In our sleep, pain that cannot forget,*
> *falls drop by drop upon the heart until*
> *in our own despair, against our will,*
> *comes wisdom through the awful grace of God.*
> —*Aeschylus*, Agamemnon

Heavy rains blanket Florence. The Arno's rushing waters rise again as a humid fog sweeps down from Fiesole to the north. Deep sadness grips us tightly around our throats as we think of our friend Esposito, especially after his recent phone call that left us chilled.

He's more desperate than when we found him last. His world is closing in on him. Another fight broke out at his home. His fiery youngest daughter unleashed a new tirade of accusations. He lost his temper and

threw a chair against the wall, smashing it. He rambled about making a decision once and for all.

Then the line dropped. I tried calling again, in vain. No answer. Again. No reply.

Days pass and still no news from Angelo. Then one morning the phone rings. It's Rita. She's alarmed. Her father has gone missing for four days. She's worried for him, and also for her mother.

"Please help me find him," she pleads in fear. "He's gone crazy!"

If Rita calls us, the situation is serious. Of all the daughters, she has always been the closest to her father. We discuss and decide that I should stay here, working on my book. Idanna will take the first train down to Naples.

"In these kind of situations, Terry, you're a basket case," she says. "I'll call if we need you."

I nod, knowing full well she's right.

* * *

The following morning, Idanna steps off the Eurostar and crosses the familiar Stazione Centrale of Naples, quickly heading to the taxi stand. A headline at a newsstand reads: "Shoot-out in Forcella . . ." Another gang war has begun. Traffic snarls under the relentless rain. She doesn't go straight up to Paola's house, but instructs the driver to drop her off at the enormous white church of the Girolamini, where we last found Angelo amid the rubble. It's noon as she enters under the maze of scaffolding. The freezing air and humidity seep into her bones. The church is deserted. No sign.

Following her instinct, she meanders across Spaccanapoli, where everything now seems familiar. In the downpour, she recognizes buildings and faces. It takes her some time to retrace from memory the way to the Office of the Museo Aperto on Vico San Paolo, all the way up Via dei Tribunali, where Angelo normally punches in his card. By the time she gets there, of course, it's closed.

The storm builds and sweeps across the city. Along the bay, frothy waves slam into the stone walls lining the corniche, sending plumes of salty spray with each impact.

When Paola answers her doorbell in Posillipo, she finds her friend Idanna standing there, drenched from the rain, trembling from the cold, and holding her small, soaked suitcase. She looks like a water-logged immigrant who has miraculously made it ashore.

Chapter 22

THE PRAYER OF CARAVAGGIO

And now here is my secret, a very simple secret;
it is only with the heart that one can see rightly,
what is essential is invisible to the eye.
—*Antoine de Saint-Exupery*, Le Petit Prince

Early the next morning, Idanna leaps out of bed, drinks her caffé, and continues hunting down the guardian's supervisor. Inside the Kafkaesque maze at the city office, she manages to find his room. Behind a desk piled high with papers, the haggard supervisor lifts his tired, dark eyes and answers her question, mumbling that Esposito hasn't punched his card for five days now.

"He did not look well, and asked for a week off. I told him he could take it out of his vacation."

With little else to go on, Idanna repeats the pattern and returns to the city office each morning, hoping to catch him. Each evening, Paola repeats her mantra of warnings, unable to understand our friendship with Angelo. Every night before sleeping, Idanna calls me and gives me the news of the day.

One morning, Idanna finds his card punched. And she immediately chases down the supervisor.

"Yes, he showed up just after eight," he tells her. "But you won't find him at Girolamini; he's been transferred."

"Where?"

"Back to the Pio Monte."

"What?"

"I got the notice from the central office of the Comune."

Idanna gives me the news. Rushing down Via dei Tribunali, she keeps talking on her mobile until she enters the church. And there, seated in the front row, she finds the guardian, gazing up at the Caravaggio. She touches his shoulder, startling him.

"Where have you been?" she asks impatiently.

"I'm back here. Whom do I have to thank?"

"The angels in the painting," she says, with irony.

"Not only . . . you and Terenzio are also my guardian angels!"

* * *

From that moment, Idanna goes over to the church every day near closing time at 1:00 p.m. to find Angelo. Often they have a bite together and she listens as he recounts recent events. But he tirelessly insists on revenge—the birthright of every cuckolded Italian, as well as Neapolitan, male.

Sometimes they remain seated in front of the altarpiece, where he seems freer to pour out his living nightmare. Memories of twenty-five years of marriage haunt him. Lucia continues to come to the apartment every morning after he's gone. She has a key. When he returns for his quick lunch and siesta before heading off to his night job, he finds the home clean, all beds made, clothes washed and ironed.

"I can't sleep in that house anymore," he laments. "I feel her everywhere. I'm gonna crack up!"

During these exchanges, Idanna challenges him to draw strength from the painting he knows so well, and also from Caravaggio's life.

"Then I go and kill the bastard!"

"The death of Tomassoni, did it resolve anything?" she says. "It haunted Caravaggio until the end, isn't that what you told us?"

Angelo looks away nervously.

"What's he saying to you?" she asks, her eyes on the painting. "And what have you always told us? Listen to the maestro's plea. Open you heart, Angelo. Can you ever forgive Lucia?"

Idanna knows full well that any man, even the most liberal Manhattan male, would rarely be able to submerge his ego to welcome his wife back in such flagrant conditions, let alone someone from the traditional Italian south.

"I tell you, she'll come back," Idanna insists with energy.

"No, I disgraced her in front of everyone. She'll never get over it. Better I go to America."

"Let me see your daughters," she says.

"It won't help. They blame me."

"The painting, Angelo. How many times have you spoken about compassion?"

Idanna notices that each time she mentions the seven acts, it has a calming effect on him. Angelo's inner anger and impulsiveness seem to lose ground.

Idanna presses. "Do you want her back?"

The guardian closes his eyes and nods silently.

"Then it will happen, but you must trust me and follow what I suggest," she insists gently.

* * *

Angelo grabs the steering wheel and turns the ignition of his Lancia. He again says, *"Grazie, nonna,"* then slides his gearshift into first. His tires screech as he accelerates, swerving past other cars on his winding way out of town. The road ascends steeply out of the labyrinth, curving back and forth, climbing the hill. Idanna sits next to him.

Below, the great port sprawls with cement warehouses, rusting ships, and rotting trash. From this vantage point, the city has a far different aura than her grandmother's villa perched over the azure sea. Whipping around the curve just in front the Museum of Capodimonte, he misses an oncoming Fiat by a hair.

"Dio mio!" Angelo blares his horn instinctively but doesn't slow down.

Once atop the hill, they race through the streets and urban sprawl constructed in the sixties until finally they pull up in front of his tenement building in Piscinola. In these Camorra-ridden housing projects

on the city's periphery, journalist Roberto Saviano describes the air as smelling *"like war, you can breathe it through every pore; it has the rancid odor of sweat, and the streets have become open-air gyms for training to ransack, plunder, and steal, for exercising the gymnastics of power."*

Idanna opens her side door while Angelo nervously padlocks the steering wheel. They enter his apartment building and he points to the graffiti-stained stairwell. Huffing up the stairs, he apologizes for the elevator that is still out of order. They walk up and arrive on his floor as a steely-eyed girl turns the last bolt of an iron gate across from his door. Angelo tosses out a quick salute. She flashes a cold glare in return.

He clicks open his lock and they enter his flat.

"The capo's daughter."

"Across the hall?"

He nods. "After her father's arrest, the family welded that gate in front of their door to keep the police at bay. "

"A bunker," Idanna says.

"That's right."

Eposito's home is empty. No one is there. The small entrance opens to a living room on the right, and on the left a modern kitchen bathed in gentle sunlight. Everything is pristine, tiled floors and all. Angelo's bedroom is cozy and impeccable, just like the daughters' two rooms with posters of pop stars plastered on the walls.

Idanna had imagined public housing in Naples quite differently. She finds the place so welcoming and well kept that it confirms her intuition about Angelo and Lucia. "This family is special," she says to herself.

"You're wondering about my kitchen?" Angelo abruptly asks, reading her thoughts. "It's thanks to the same lottery. I bought the Lancia, made the kitchen, and I also tiled the bathroom."

"Luck in Naples seems to strike more often than in Florence," Idanna says with quiet disbelief.

"It's because your dreams aren't linked up with numbers. When I worked in Grosseto, I stopped dreaming altogether," he confides, standing in front of a large photo of him and Lucia with Rita as a baby. It hangs at the entrance like a painting.

The apartment walls are covered with such pictures. No wonder Angelo has sleepless nights. Remembrances of times past. Lucia's riveting eyes spark in virtually every photo. Angelo's smile is as broad as his shoulders. Those were happy times.

"Angelo, listen to me," Idanna says firmly. "All these photographs? You must put them all away."

"What?"

"Let's begin now!" Idanna starts by taking down the large one by the door. "Then you're going to write a letter to Lucia. I can help you. She'll find it tomorrow when she comes . . . now listen what I have in mind."

Idanna carefully composes the text.

"My dear Lucia, please understand and don't take it personally. I have to calm down and accept what has happened. I must forget. I can't have all these pictures in front of me now. My friends have invited me to New York for a while. I've already asked to take my vacation, so I'll be going soon. In America, if I find someone who needs a maestro pizzaiolo, I'll try to stay, and send money for the girls. Otherwise I'll come back and live somewhere else. Our daughters need some stability. . . . etc."

Angelo smiles, surprised. "Are you really taking me to New York?"

"Well, actually, no. Only to Florence, but no one needs to know that. No one! You understand?"

"Yes, but what do I say to my daughters?"

"Well, speak to Rita first. She'll pass the word for sure. They all have to think you're leaving for America. They all have to realize that they may be losing you."

"But it's a lie!"

"A white lie, and it may save your family."

"And what if they're happy to see me go?" Angelo counters.

"That's the risk you've got to take."

"I've nothing left to lose." He relents and opens a cupboard. "Here, give me some of those photos. The big ones over there . . ."

Within half an hour the house looks bare, as if stripped of its soul. Tables cleared. Empty patches on the walls. Much less inviting.

Sitting at the kitchen table, pen in hand, Angelo seems energized. Idanna slowly dictates, and he writes down the crucial message to Lucia. Once the letter is done, he lights a cigarette, dragging heavily on it. Smoke billows around as he exhales.

"Idanna, I've felt the whole weight of the world on my shoulders. Just look at how much I've shrunk." He shrugs with a dose of self-mockery. "But now I feel lighter!" It's his first laugh in three months.

That very evening, I get a sudden call from Angelo. He describes in detail the *tour de force* at his house, even though he knows perfectly well that Idanna has already briefed me.

"My daughters are furious about the photographs. I told them the photos stay off the walls until I leave for New York. Well, that quieted them down. For once Chiara didn't snap at me."

"So, you've started a revolution."

"No, Idanna has. Who knows where it will end." Then he announces, "Terenzio, I've stopped smoking."

"What? I don't believe it!"

"That's right. No more cigarettes."

"But you smoke two packs a day, how can you manage?"

"I will. I must, to strengthen my self-control."

"But in crisis, people usually smoke twice as much."

The guardian never ceases to amaze me.

Chapter 23

BLESSINGS FROM FALLEN ANGELS

In Naples, there is no private grief, no private misery.
The grief of the individual is the grief of the entire city,
the hunger of one man is the hunger of all.
—*Curzio Malaparte*, The Skin

*F*ists fly. Arms shove. A young boy screams with pain. Caravaggio watches two kids roughhouse in the piazza.

The stronger one grabs his friend, who twists away like a fish escaping a net. The boy reels to the right. A woman throws her arms up in panic. A beggar howls in fear of being trampled. The boy stretches his arm downward, with his hand open to brace the fall. His friend catches him. Just in time.

Caravaggio waits a moment and then approaches the two boys. He needs models for his angels. As they listen, both calm down. Angels? The word bewilders them. This artist must be blind. They've been called many things, but never angels.

Fascinated by his request, the kids enter the Pio Monte Church. Inside, the hullabaloo of the street dies down. They stare, dumbfounded, at the immense canvas with a stepladder in front.

"Here put these on!" Caravaggio tells the scugnizzi. *The street kids look at him in a daze. The artist takes a pair of wings and ties them onto the older boy's back. "Stand here," he instructs. The lamp lights up the feathers. Then he places another set of wings on the younger lad. The two giggle,*

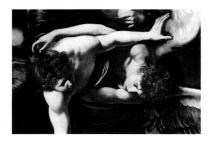

amused, while the artist climbs up the ladder with his palette and brush. From that perspective he will paint the angels.

Looking straight down, he directs the younger one. "Now, put your arms around your friend!"

The older one instinctively pushes him back with his left hand.

"That's good, push his wing away! Yes, just like that!" The maestro works quickly. "Now, extend your other arm, open your hand, as if you're falling." The older boy obeys.

"Open your hand!" the painter shouts as his brush captures the tension in the lad's extended arm. His position on the ladder allows him to portray the angels from the perspective of flying alongside them.

But something radical happens. Angels never cast shadows. Never. They're from the spirit world. They have no physical form. But in this painting, they are not just spirits. Their wings cast long shadows on the prison wall. They are solid beings of the flesh. Why? Because the display of human solidarity they notice from above is so moving that they're pulled into our earthly realm.

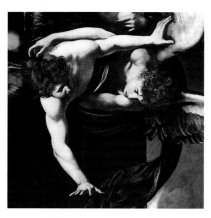

The older angel has eyes only for Pero. A magnetic force more powerful than the heavens seems to have taken over his celestial being, wings and all. His hand appears ready to cushion his free fall. But the other angel holds him up in flight.

The open, outstretched hand connects the spiritual realm with the human world. It also blesses the scenes unfolding below.

Chapter 24

MIRROR OF THE WORLD

God changes his appearance every second.
Blessed is the man who can recognize him in all his disguises.
 —*Nikos Kazantzakis*, Zorba the Greek

*T*he seven founders won't give in. Nor will the painter. The *heated argument has gone on for days. The founders demand that Caravaggio include the Madonna in the altarpiece above the angels. But the painter wants to include only Jesus.*

After another sleepless night, the maestro knows he has no choice but to comply.

At sunrise, he goes out to search for a mother and child. He has no luck. The following morning, he does the same. The street is already busy with carts and foot traffic. As he rounds a corner, he feels a few drops fall on his head. Rain? Peering up, he notices clouds of a gathering storm. His gaze also catches the face of a lively child held by his mother next to a high window.

"There he is!" the artist bellows, and quickly tries to draw the attention of the mother.

She sees him and calls down to the waving man. "Good morning!"

"Signora!" he shouts back. "I need you to pose for me with your child."

"Are you the painter at Pio Monte that everyone speaks about?"

He nods and gestures toward the church.

"I would be honored!"

Later that morning, when the young mother pushes the door ajar and enters the chapel, she gasps in wonder at the painting looming vertically in front of her. Caravaggio points at the upper part of the canvas.

"I will place you above those two angels just as I saw you this morning, looking out of your window."

"Holding my ciccino!*" she assents, kissing her adored child.*

"Yes, with your little one."

He starts at once, hoping to capture the child before it's too late. The baby boy is falling asleep, and that must not happen. His face must be more prominent than his mother's. Her role is simply to hold him.

After all, the painter's entire effort with this painting is to crystallize Jesus's words before he was taken away. Caravaggio first heard these words repeated in the Duomo of Milan by Cardinal Carlo Borromeo, and he was deeply touched.

Later, in Rome, he was drawn to the charismatic Filippo Neri, who asked: "How can any Christian turn his back on the poor?" Neri labored among the sick and the destitute, pilgrims and prostitutes. Like Socrates, he traveled across the city, conversing with common people. Followers gathered for evening dialogues in his Congregation of the Oratory, for which Car-avaggio painted The Entombment of Christ. *Meanwhile, the Princes of the Vatican, oblivious to Christ's teachings, lounged in their beds of luxury in red robes and gold. Their waistlines bespoke fine dining and feasting.*

In his final sermon before his crucifixion, Jesus addresses himself directly to all those who pretend to appreciate his words, but then betray all the principles:

> "For I was hungry and you gave me nothing to eat.
> I was thirsty and you gave me nothing to drink.
> I was a stranger and you did not take me in.
> Naked and you did not clothe me,
> Sick and imprisoned and you took no care of me."

And those who plead innocence will argue that they did not see or know.

"Lord, when did we see you hungry or thirsty, a stranger or naked, sick or imprisoned, and did not help you?"

He firmly rejects their lame excuse.

" . . . whatever you did not do for these, you did not do for me."

Caravaggio is now alone. The young mother has left with the child sleeping in her arms. He scans his giant canvas and dips his brush into the lead white paint. On the lower left corner, he adds another layer to the naked man's back until it glows like the sun. He then climbs the ladder and delicately places the last touches on the face of baby Jesus, who locks his gaze onto the lowest figure below.

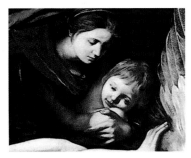

The infant stares down at the man crawling in the dust as if he has seen him before. The child is that broken man.

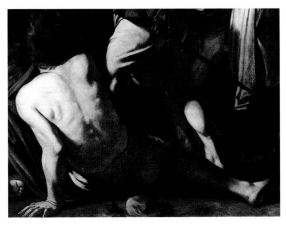

I am that homeless sitting on the corner.
I am the sick woman struggling down the street.
I am the starving man whom you passed by yesterday.
Deny them and you deny me!

Three hundred fifty years later, in the slums of Manhattan's Lower East side, Dorothy Day will gather a group of volunteers on the Bowery during the Great Depression. Founder of the Catholic Worker movement, she will live and die simply by this radical vision. Unlike Mother Teresa, she will find her Calcutta on the streets of New York with the poor and the homeless. She writes:

"If that is the way they gave hospitality to Christ, it is certain that is the way it should still be given. Not for the sake of humanity. Not because it might be Christ who stays with us, comes to see us, takes up our time. Not because these people remind us of Christ . . . but because they are Christ."

Part 3

THE REWARD

Chapter 25

SPUMANTE AT MIDNIGHT

The heart's memory eliminates the bad and magnifies the good; and thanks to this artifice we manage to endure the burdens of the past.
——*Gabriel Garcia Marquez*, Love in the Time of Cholera

Angelo's letter to Lucia apparently created some commotion. The photos stayed in the cupboard only three days, then the girls put them all back where they belonged. At that point, Angelo announced he was leaving for New York the next day, but instead he planned to catch the train to Florence.

On Monday we stand waiting on the platform at Santa Maria Novella station, but our friend does not arrive. We try to call him, and again his cell phone is turned off. We are unable to reconcile his new disappearance with his latest behavior. In suspense, we wait for news.

But then, on Friday, we hear from him. He animatedly recounts everything. His daughters had conspired to prevent him from leaving. They stole his key, locked him in the house, and took away his phone, leaving plenty of food in the fridge.

"Luckily, I had been given leave," he says. "Otherwise I would have been sacked! But my girls pulled off this stunt, what do you think? They must really love me!"

Idanna assures him, "Of course they love you!"

"But when will I see you again?" he asks. "I miss the two of you."

* * *

And so on a dazzling day in November during the so-called summer of St. Martin, when one last burst of warmth descends over Italy, we find ourselves again at Pio Monte. Esposito welcomes us with a long embrace. Standing in front of the Caravaggio, he announces proudly, "Look, this time, I'm here to stay, at least for a while."

At that moment, a throng of children file into the church, surrounding him, all eyes turned toward the painting. Angelo winks at us and begins the story, holding them instantly in his spell.

We still can't believe that President Leonetti remembered and persuaded the city to reappoint Esposito as guardian of the church. The count's parting words to Idanna, repeated now by Angelo in his own way, ring in the air.

"Caravaggio left a message for every age, race, and social class."

We listen along with the kids. It feels like our first encounter, fresh and enthralling.

Later we wait near old Giovanna's table for the guardian to close up. When all is taken care of, I hand him a note I've been saving. It's a quote from a famous play by the adored Neapolitan theatrical genius, Eduardo de Filippo, to whom our friend Paola was close. Angelo reads it out loud.

Do you know what makes a woman cry?
When she knows what happiness is
but it's beyond her reach . . .

Giovanna laughs, shaking her head. *"Filumena Marturano,"* he says, recognizing the heroine of the play. *"Gran donna . . .* a great woman! Ahh," he realizes, turning to me, "you're thinking of Lucia?"

"Have you seen her?" I ask.

"No! But the girls say she asks about me. Perhaps she's worried I may leave."

"I'm sure she is," Idanna interjects. "Your girls too."

"New York!" Angelo throws back his head. "It has always been my dream . . ."

Giovanna breaks into her trademark grin, overhearing the mythical words. I offer to get him a pack of her contraband Lucky Strikes.

"No, I told you, I quit."

"And I lost my best client!" sighs Giovanna. "Poor me!"

"I'll never leave you, my doll," says Angelo, kissing her cheek.

We leave the piazza. The guardian is in no rush to get home. So we stroll down the so-called "street of the shepherds," passing the long bazaar of brightly lit shops displaying carved angels, sheep, cows, donkeys, and countless holy families, and I pick up three little statues representing the mages.

"Every year on the sixth of January," Angelo says, "the three kings ride on horseback in a grand procession through these streets, carrying gold, frankincense, and myrrh for the little one."

"You know, the mages were from Iran," I tell Angelo. "Zoroastrian priests."

"Zorro who? I thought they were kings!"

"About 2,500 years ago, there was a sage called Zoroaster who predicted the coming messiah. His priests were also astronomers and scanned the skies for the signs."

"And that's how they saw the famous star."

"Yes, for weeks, a bright nova burned low on the western horizon in Pisces—the sign of the Jews. This gave them enough time to travel . . . oh, never mind."

". . . and arrive to little Gesù," Angelo interrupts with his hand. "This part I know!" Taken aback by all the new information, he then asks, "By the way, why do you have to leave so quickly back to Florence? I need you here."

"You can always take the train up to see us. But whatever you do, tell your girls you're going to America."

"I promise!" And with that, we part ways.

* * *

A month later, on Christmas day, Angelo's voice vibrates with new life. All the family is gathered at Rita's house, and he describes excitedly who's there: Maria and Anna with their fiancés, both called Giuseppe,

Beppe for short; the ebullient Chiara, wise Rita with her four daughters, Vanessa, Carola, Suzy, and Nadia, with their father, Tony. And then there's Lucia.

"Yes, Lucia is also with us!"

He tells us that she was cooking when he arrived and did not turn around to say hello, but he felt as if she had. She has lost weight and has a new haircut, a bit too short for his taste. She's wearing a black dress that glitters like a starry night and follows her gentle curves.

Angelo speaks poetically, sharing all these details without catching his breath. In the background, we hear a lot of festive noise, music, and laughter. Then the phone goes dead. A few minutes later, there he is again.

"Happy birthday, Idanna!" he shouts out. "And *Buon Natale* to Terry!" Then, before we can reply, he passes the receiver first to Rita, then Maria, Anna, and Chiara, who bestow on us a raving Neapolitan chorus of holiday wishes, *auguri*.

Six days later, our planet turns to face the New Year and coming of the New Millennium. We are back in Naples, dancing and celebrating with thousands of people in Piazza del Plebiscito to the popular rhythms and songs of the adored Lucio Dalla. Our friends, George Rush and Joanna Molloy, hard-boiled columnists from the *New York Daily News*, have also joined us with our young godson, Eamon. Flaming waterfalls cascade off surrounding rooftops as the music rocks us in the piazza, ablaze with Roman candles.

Neapolitans are famed around the world for pyrotechnics. Even in the deepest crisis—aerial bombardments or ever-mounting garbage—celebrations continue, and no feast can be complete without painting the skies with phosphorescent thundering flowers that blossom in hot ruby, liquid gold, emerald green, crystal white, and lapis blue.

Just before midnight, the excited crowd surges down to Santa Lucia, the waterfront facing Castel dell'Uovo. Explosive fireworks shoot across the immense starry sky, illuminating Vesuvius and the bay. Gasps, cries, and full-throated yells erupt with each explosion. When the spectacle peaks at the grand finale, everyone cheers with gusto. Slowly the crowd filters away, and as the night draws to a close,

we wonder where our friend Angelo is at this historic hour. The question lingers in our minds as we walk up the hill of Posillipo back to our Neapolitan home.

We stop in front of Villa Pavoncelli. The Pompeii-red of the walls is now enveloped in the vermilion hues of a new dawn. Terraces of healthy palm trees and climbing orange and purple bougainvillea cascade down to the small beach where Puccio and Emilio built the fantasy sand castles . . .

* * *

January first. A ringing phone wakes us. Angelo speaks with locomotive energy, too fast to understand. I hand my cell over to Idanna.

Within a second, she exclaims, "No!"

She is fully awake now. "What a lovely way to begin the twenty-first century!" I lean in to listen.

"Lucia's back home!" he cries out again. "We're all reunited."

"Angelo, please, it's so important," Idanna urges. "These are your first days back together. It won't be simple."

"I know. I know."

"Don't mess it up."

"I won't."

"Never bring up the past."

"I promise, my angel."

"No questions," Idanna reminds him. "Be gentle. Give her time. Love her. She's back home now. Never forget how desperate you were. This is a miracle."

"I know," Angelo answers. "One wrong word, and all is lost."

He once again arrests us with his understanding.

"I have to see you both before you leave." He insists on meeting later that day. "You bring me good luck. I won the lotto a second time!"

So we agree to see each other in Mergellina just down the hill.

When the door of Restaurant Ciro swings open, at last we meet Lucia. She's a handsome woman in her early forties with short black hair, high cheekbones, and burning brown eyes. She looks exactly like

the photo in Angelo's wallet. She shakes my hand and embraces Idanna with tender shyness that contrasts with her strong eyes.

We trade pleasantries. It's clear that she's happy to meet us at last. But I wonder how she really views our friendship with her husband. In the distance, a huge passenger ship slowly sails out to sea. Lucia glances at it and turns back quickly.

"Were you going to get on one like that?" she asks, looking at Angelo, with a touch of anxiety in her voice. Her timidity disappears with a shot.

"A ship? Not at all! When I go, I'll take a plane," he jokes, caressing her cheek.

"Was it your idea to bring him to *Nuova* York?" Lucia probes, not sure of whether we were to blame.

"Yes," I reply. "But he's still here, so we've come to Napoli instead."

Clearly she's a spirited woman, as feisty as Angelo. Soon we are all laughing like old friends. Our glasses fill with *spumante* and we raise them to toast all the good things that life has brought us.

Our friend, the guardian, has evolved into a man beyond expectations. Lucia looks at him with troubled admiration. He has traveled to Inferno and back, like Dante. Purgatory suits him well.

Chapter 26

THE UNVEILING

There are painters who transform the sun into a yellow spot, but there are others who transform a yellow spot into the sun.

—*Pablo Picasso*

*I*n the final six weeks, Caravaggio opens the door only to his assistant for the daily ritual of grinding colors. The pigments are relatively few: lead-tin yellow, carbon black, red and yellow ocher, vermilion, malachite, and lead white. With mortar and pestle, Gennarino goes to work. Once the powders are ready, he leaves.

The church is quiet. Caravaggio doesn't need his models anymore. Now he can work in total solitude. The silence is soothing.

He moves Samson from the center slightly to the left, and in the center he places the outline of a column in homage to his "godmother," Costanza Colonna, and her family.

At last he can refine the light and darkness of the composition. Using lead white and yellow oils, he lightens the darkened black and earthly tones on walls and stones. Each brushstroke brightens the faces and flesh of the characters. He casts a delicate cool-white glow on Pero's breast and cheeks. The back of the naked man radiates translucent yellow. The torch burns its flame.

Light floods across the scenes from the left. The players now appear three-dimensional, revealing nature as it is. Caravaggio brings his painting to a high finish. His inner light shines with divine grace.

We die containing a richness of lovers and tribes, tastes we have swallowed, bodies we have plunged into and swum up as if rivers of wisdom, characters we have climbed into as if trees, fears we have hidden in as if caves.

I wish for all of this to be marked on my body when I am dead.

—*Michael Ondaatje*, The English Patient

Caravaggio completes his masterpiece in only three months. An extraordinary achievement. Personal turmoil and a sense of urgency have driven him to work feverishly, night and day. Donna Costanza's arrival is imminent.

The unveiling of The Seven Acts of Mercy *takes place before the astonished founders and their guests on January 9, 1607. The theatrical contrast of light and darkness, combined with his uncanny naturalism, leaves the viewers stunned. The figures appear to be on stage as if seen from the front row.*

The reaction of the young patrons is magnanimous. Their dream has been realized. They announce that the altarpiece must never be moved nor sold. Caravaggio shakes the hands of the founders with a sigh of relief. In Rome, reactions to his works have not always been so positive. The Madonna and Child with St. Anne *never got to decorate a chapel of St. Peter's Basilica; his first* Conversion of St. Paul *was refused; the* Death of the Virgin *was rejected by the fathers of Santa Maria della Scala and was quickly sold by its commissioners. And there had been more.*

Instead, this work is a triumph. It will mark a turning point for local artists. It will transform their style and shift the center of gravity from Rome to Naples, raising the local school of painting to the finest in Europe. The Neapolitan Seicento.

Caravaggio basks in this moment of glory. From January until the end of May, he will work on the Madonna of the Rosary *that will prominently feature his host, Luigi Carafa-Colonna. But then threatening rumors begin to haunt him anew. A courier arrives undercover with a message from Rome. Pope Paul V's pardon seems remote. The painter's head is worth a fortune. Bounty hunters are on the loose. Caravaggio knows he must prepare to escape farther south. His patroness Donna Costanza urges him to leave with her son.*

The moment has come: Caravaggio must abandon the city that has given him new life. Now he will put his fate in the Order of the Knights of St. John, who defend the Mediterranean seas from the feared Ottoman navy. Only thirty years have passed since these knights fought at Lepanto alongside the Holy League led by Marcantonio Colonna, Costanza's father.

Docked in the harbor, a fleet of galleys is set to sail under the command of Costanza's son, Fabrizio Sforza-Colonna, who knows the artist well. He and the painter played together as children in the town of Caravaggio, and they had never lost touch.

Caravaggio will sail to Malta. He carries Costanza's letter of introduction to the grand master, informing him of the painter's search for a safe haven. The famed fugitive will offer her letter and his brush to the famed military order of knights.

In secrecy, one early summer morning, Caravaggio heads down to the brine-sprayed docks.

Waves splash against stone walls.

The galleys are waiting.

Drums are pounding.

<p style="text-align:center">* * *</p>

A wind blows from the east. Long oars cut into the frothy sea. Each stroke beats to the cadence of a drum. The galley's wooden prow slices westward into oncoming waves as it chases the setting sun.

Salt spray settles on Caravaggio's face. With the sea breeze blowing through his black mane of hair, he feels a sense of relief. Below the deck, slaves groan and chant to the pounding drum. The warship's pace is impressive. Maltese galleys are the fastest in the Mediterranean.

Sailing alongside the cliffs of Capri, the royal capital fades behind him in the distance. As the galley rises and falls in the waves, his gaze settles on Vesuvius that looms on the horizon. The cone shines bloodred, lit by the dying rays of the sun. Below, in its shadow, the city lies.

Caravaggio takes one last look and reflects on the luminous church where his painting will hang forever. In that moment of June 1607, he cannot imagine that four hundred years later, his art will strike a fateful chord in a humble man born around the corner, in the Alley of the Sun.

Chapter 27

HIS PROPHETIC TESTAMENT

. . . and when he shall die, take him and cut him out in little stars, and he will make the face of heaven so fine that all the world will be in love with night and pay no worship to the garish sun.

—William Shakespeare, Romeo and Juliet

*C*aravaggio sails from Naples to distant Malta, then onto Sicily, and eventually back to Naples. He returns a hunted man. When he is attacked, Costanza will nurse his head wounds and ravaged face, while pleading to the powers in Rome for mercy. Cardinal Scipione Borghese—a great collector of art, and the pope's nephew—also lobbies to lift the artist's death sentence. Finally, a promising message arrives. The Holy Father may allow the artist to return. Caravaggio, in spite of his wounds, hurriedly goes to work to prepare three paintings as offerings to the cardinal. Once he is finished, he rolls them up and sails north toward the eternal city.

Only days before the pope signs the pardon, news of the artist's death quickly spreads in Rome. Vultures begin to circle in search of his paintings, not his body. His last three canvases sail back to Naples and are then handed by the boat's skipper to Donna Costanza.

Strangely, two of these paintings will never be found. The mystery remains. Only St. John the Baptist *will eventually reach Cardinal Borghese, whose villa above Piazza del Popolo still boasts one of the greatest art collections in Europe.*

Yet, three years before his death, Caravaggio had already mapped out his fate on the altarpiece of Pio Monte. In his final months, he suffered hunger, thirst, and sickness; he languished in prison and sought shelter, and died without last rites. No tavern keeper, no passing knight, no priest, not even his vigilant Costanza could come to his rescue or simply be at his side. The Seven Acts of Mercy *was his painted legacy.*

* * *

Caravaggio could not have imagined his key role in defining seventeenth-century Italian art. Younger artists in Naples will imitate the maestro's style. His influence will travel north to the wealthy Netherlands and its burgeoning merchant cities of Utrecht and Amsterdam. Rubens will purchase one of his paintings for the Gonzaga of Mantua and copy his Entombment of Christ. *Velazquez, Bernini, Hals, Rembrandt, and Vermeer will also follow his lead.*
 But the tides of popularity will eventually swing away from him.
 His name will be cast aside. Fallen from grace.
 Three hundred and fifty years will pass.

* * *

And he sets his mind to work upon unknown arts . . .
 —*James Joyce,* Portrait of an Artist as a Young Man

In 1951, a groundbreaking exhibition in Milan curated by the art historian and critic Roberto Longhi will create a stir. The art world exhumes Caravaggio. His reputation is dusted off. Even the art connoisseur Bernard Berenson declares, "With the exception of Michelangelo, no other painter exercised so great an influence."

Other art historians will anoint him "the father of modern painting." As his fame increases, a cottage industry will grow among all those afflicted by what Angelo Esposito calls the "Caravaggio disease."

In the visual new arts, he will find fans and followers.

"Caravaggio invented Hollywood lighting," says David Hockney, the noted English artist, "a black world that had not existed before, certainly not in Florence or Rome."

Many feel that the genre of "film noir" owes him a huge debt. The director Derek Jarman echoes Hockney's words. "He invented cinematic light . . . Every Italian cameraman is grounded in Caravaggio." Not only Italian. When the cinematographer Gordon Willis staged his lighting in the interiors of Coppola's *The Godfather*, surely he had Caravaggio's chiaroscuro in mind.

"He would have been a great filmmaker," declares director Martin Scorsese. "I was instantly taken by the power of Caravaggio's pictures. You come upon the scene midway and you're immersed in it. It was like modern staging in film: it was so powerful and direct . . ." Scorsese admits that the maestro's influence is all over his *Mean Streets*: in the camera movement, the staging of scenes, using street people, and more. He refers to this film as *The Calling of Matthew* in New York. And in *The Last Temptation of Christ*, he confesses that he was greatly inspired by Caravaggio.

* * *

But, in the end, no one has ever discovered the truth of his tragic end, how he died, or who killed him. The speculation is unnerving and the list of suspects is long; a suitable pursuit for academics seeking the holy grail of publication. Yet the mystery over his lost body still gathers force. Competition over his bones spawns surreal events.

In the tiny Italian seaport of Porto Ercole, in 2010, a skeleton will be exhumed from a seventeenth-century grave. With much fanfare, the bones are taken to Ravenna for scientific tests. Professor Giorgio Gruppioni announces that there is a 75 percent probability that this is the body of Caravaggio. The bone—a fragment of the frontal part of the skull, two jaw pieces, a femur, and a fragment of the spine—are then put on macabre display for journalists who flock from around the world.

Immediately after, politicians from Milan proclaim their wish to return the artist's remains to his ancestral hometown. Front-page articles of the *Corriere della Sera* and *La Stampa* debate the issue. Thankfully, the mayor of Caravaggio intervenes to stop this charade. He demands that the remains of this nameless soul be respectfully taken back to its original peaceful resting place.

However, in a final blaze of self-promotion, a man strides onto the media stage. Cesare Previti, Berlusconi's devoted lawyer and his former Minister of Defense. Later convicted for corruption and forced into house arrest and social work, Previti seizes on the controversy and sails to Porto Ercole with the human bones stored in a Plexiglas urn aboard his yacht, *Barbarossa*. He catches the last glare of the television cameras and journalists hunting for the painter.

From Naples, art historian Professor Tomaso Montanari comments on the event in the popular Italian daily *Il Fatto Quotidiano*.

"If art history is being transformed into a three-ring circus, credit must be given to the superficiality of art historians who are among the most uncommitted and opportunistic of the humanists."

Chapter 28

A LETTER FROM ANGELO ESPOSITO

I am part of the sun as my eye is part of me. That I am part of the earth my feet know perfectly, and my blood is part of the sea. My soul knows that I am part of the human race, my soul is an organic part of the great human soul . . .

—D. H. Lawrence, Apocalypse

A few months before the New York publication of my book chronicling my family's odyssey back to Iran after thirty years, Idanna receives a letter from Esposito with his surreal address on the back of the envelope.

Angelo writes as if he were picking up from where he had left off. In the first part, he announces excitedly that he has been selected to take a course in art history sponsored by the city. He also tells us that His Royal Highness, Prince Carlos de Borbone—descendant of the kings who ruled southern Italy until 1861—is scheduled to arrive. It will be an historic visit for Neapolitans, considering their 400-year link with the Spanish, before Garibaldi's redshirts sent them scurrying into exile. The prince has expressed a wish to see the Caravaggio.

"And guess who has been selected to explain *Le Sette opere di Misericordia*, not a leading art historian, but your friend Angelo!" He can't quite believe it himself.

He writes that great changes are happening at Pio Monte, and that he's very busy because visitors now flock in great numbers. Caravaggio's

painting is now a highlight of Spaccanapoli, as if it had just been unveiled. The quiet days of emptiness and silence are long gone from the church. Angelo, like the painting, is thriving.

The second part of his letter takes a strikingly different tone.

. . . Listen, listen my dear friends, together, we must rehabilitate his name and give him the redemption he so much deserves. Perhaps we will attract the anger of all those experts who have written on Caravaggio; those who have researched him, without ever having 'lived' with him or been at his service as I have for the last ten years.

I came from the streets, and for me this has been a huge honor, I mean the opportunity to coexist with such an artist on a daily basis. I am now deeply into this experience—perhaps the most beautiful one in my life—an experience that has opened for me the doors of goodness and self-reflection. More importantly, it has made me understand the importance of forgiveness. It is the capacity to forgive that Caravaggio has given to me, the greatest gift I could receive.

Of course, I also owe so much to my two angels, to you and Idanna. I will always carry you both in my heart.

Never forget that we are faced with the most beautiful painting in the world, a painting that heals the soul and holds the secret for happiness: Love your neighbor as if he or she were yourself.

It is love in its highest form. If we realize this, everything will fall into place. Next time, I will send you more stories about my youth, but now it's about the painting.

With affection,
Angelo Esposito with Lucia and family

PS Maria is expecting a baby. The family is expanding.

August 1, 2001

* * *

Sometimes, awaiting sleep, or on walks along the river to the Battery, pieces of the day come back. They are never in any order, since memory is a highlight film. But there again are the people, tiny in the high distance, leaping into the empty air beside the smoking North Tower.

—Pete Hamill, *"The Changed World"*

On a brisk crystal-blue morning, the familiar voice of Angelo crackles across the Atlantic. He shares the latest news. Anna is getting married; a heat wave in Naples; the first communion of Rita's daughters. While speaking on the cordless phone, Idanna gazes south at the Manhattan skyline and asks about Lucia.

"She's well," Angelo replies. "Now she comes with me to the pizzeria. I think she's a bit jealous."

As Angelo chatters, Idanna stares out over the rooftops, antennas and water towers. In the pristine sky, a huge plume of smoke rises from the tip of the island. The strange black cloud climbs higher and higher.

"Terenzio, come quick!" She calls out. The line with Angelo goes dead.

I rush over to the window. In stunned silence, our eyes are locked downtown. I turn on the TV. One tower is burning. Then, a second plane slams into the other tower of the World Trade Center. We sit transfixed at the horror, replayed over and over as both towers fall in a cataclysm of burnt metal, wood, plastic, and flesh. A tsunami of fine white powder explodes in all directions.

Our elevator is out of order, and we run down fourteen flights of stairs. With hearts pounding, we step outside. Already blue police-barricades block all traffic south of Union Square. Not knowing what to do, we head toward St. Vincent's Hospital but are turned back. Sirens of fire engines, ambulances and police cars whoop and howl all around us. The air reeks with an acrid burning smell. Ghostly figures stumble past with eyes of lost souls, coughing and gagging.

Soon, we hear that all tunnels and bridges are closed to traffic. No one can leave the island, except on foot. We all wait for the next attack. The world watches from afar while New Yorkers lend a hand to one another.

No one stays indoors. The streets fill up as friends gather in the open air. Consoling, weeping, wondering in shock what happened and why.

An eerie haze settles over the city. The smoking crater at ground zero still burns in anger. White dust settles on car hoods, window ledges, sidewalks, porch stoops. The tallest towers of the urban world are now ashes. A blanket falls around us like the lightest of snowflakes. Pulverized concrete, steel, asbestos and death blow in the winds. That burning smell clings to our noses, hair and clothes. A bitter taste is on our tongues and it will not leave.

On the first evening, a candle-lit vigil dimly illuminates the darkness at Union Square. A statue stands witness: Mahatma Gandhi no longer seems frozen in place but walking among the distressed. Idanna and I watch the flickering candles.

Each following night, hundreds congregate—students, cabbies, teachers, winos, children, men and women of every age and walk of life—all come to stare at the trembling flames. A thousand and one candles burn across the square until dawn.

A young candle-keeper tends the makeshift altar with a ballerina's grace, carefully moving through the river of lights and melted wax, taking freshly lit candles from the crowd and finding places for them.

An immense butcher-paper scroll is rolled out. New Yorkers of every color and creed scribble down their comments. It's soon covered with signatures, pleas, poems. Gandhi's words stand out, "An eye for an eye makes the whole world blind."

Photocopies of faces and portraits of the missing are taped to lampposts, walls, and subway corridors all over the city. They stare at us as we pass by. All plead for news of beloved lost relatives or friends. "Have you seen . . ." The cult of images grows. Eyes of the missing look out from graduation photos, office parties, family pictures.

Life goes on as best it can. People wake up and go to work—bus drivers, civil servants, firemen, secretaries, shopkeepers, all keep the city together. There are even polite words exchanged on the subway, something rare for New Yorkers. Like Naples, this city is now full of spirits. They circle us. With each passing night, candles are lit and prayers are whispered to them.

Union Square becomes a Mecca of broken hearts, simple citizens, injured souls. The survivors. Straddling 14th Street's police barricades, this three-block piazza has become the Shrine of the Fallen, the Sanctuary of Remembrance. The square breathes and exhales like a living being. It gives shelter and feeds our thirst for companionship. Our desire to bear witness and honor the dead. And with each new day, the seven acts are played out in the streets, before our eyes.

We join the crowded flock and come to witness, to weep and pray, to simply stand together. In those horrific days as our stunned city reels, solidarity holds this melting pot together.

Stories of heroism and sacrifice are traded, selflessness and courage pass around the living. I think back to our guardian and to his treasured painting. During these long nights, I realize that Caravaggio's vision reaches well beyond Naples. It now embraces New York's gaping wound, cut deep into the American psyche, touching the whole world.

And the phone calls come at odd hours from around the country and abroad. Even my old friend, Hassan, manages to get through from Iran. My hand shakes as he pours out his heart.

"Allo, Ter-ry. How are your brothers, your mommy and daddy? Are they safe? We are so worried and sorry for the families of the people who died . . ."

All his loved ones are gathered next to the phone, and I speak to Fatimeh, then his daughter Maryam and each of his three sons. Then again Hassan comes on the line.

"I pray for the world," he says. And then I hear him recite a poetry written six centuries ago by Saadi, the beloved Persian poet. I listen spellbound to the same words he had told me as a child.

Children of Adam are all members of the same body,
Who, in creation, were made of the same essence.
He who does not feel others' pain,
Cannot call himself a son of man.

A day later, Angelo calls from Naples.
"Terenzio!"

"Angelo!"

"Is she with you?"

"Of course. She's right here."

"*Grazia di Dio*! Thank God!"

I hand the phone to Idanna. She speaks softly, recounting the events—what we've seen, heard, touched, and felt.

"There were ninety nationalities in the towers . . ."

"And what will happen now?" Angelo interrupts her, "All we can do is help one another. We're all in the same boat!"

* * *

Months later, we find ourselves back in Naples at the first communion of Rita's daughters, Angela and Giusy, hurled into a party with karaoke and line-dancing led by Lucia. A popular folksinger—a close friend of the family—plays her dramatic role as godmother.

The guardian informs us that he has been awarded the certificate of "Art Instructor," which allows him to speak about the painting to schoolchildren in a new Pio Monte initiative called *L'arte della solidarietà,* the Art of Solidarity.

His daughters, Anna as well as turbulent Chiara, have both walked down the aisle in joyous wedding celebrations. And the most dramatic news: Maria's new child is a baby boy. Little Angelo. A movie-size poster of the *bambino* now hangs in the family home.

Angelo takes us to meet his ailing mother, a lady with snow-white hair, very distinguished in her simplicity and fragility. Idanna cannot fathom how she could have given birth to eighteen children, and begged on buses to keep the surviving ones alive. The whole world is contained in her eyes, devoid of any bitterness. She holds Idanna's hand tightly in hers.

"This is life, my dear one," she whispers, "don't worry, keep laughing—the worst is yet to come!" And we burst out in laughter.

Chapter 29

FINAL GRACE

For a time, I rest in the grace of the world, and I am free.
— *Wendell Berry*, The Peace of Wild Things

A decade later, the guardian's dream to see Caravaggio honored comes true. An extraordinary exhibition of Caravaggio's paintings opens its doors in Rome on the 400th anniversary of his death in 2010. Entitled simply *CARAVAGGIO,* the critics buzz excitedly, hailing it "the show of shows."

A long line begins to form on a chilly morning in February at the Stables of the Quirinale and continues until the final evening in June, four months later. Over half a million spectators will wait three hours to file silently through and view his paintings assembled from all over the world, many brought together for the first time. *The Seven Acts of Mercy* is not on view. The mandate of the founders has been respected. The painting does not leave the Pio Monte or Naples.

The *Corriere della Sera* reports that the exhibition has broken all records in Italy as the most popular art show of the last ten years. The press proclaims, after numerous polls, that Italians now consider Caravaggio the greatest artist of all time.

In the eternal city that once cast him out as a convicted murderer, the artist finally finds grace.

Epilogue

Since we stepped into the small church many years ago, Count Gianpaolo Leonetti di Santo Janni has kept his word. Pio Monte della Misericordia has undergone a revolution and joined the future.

In 2004, the Caravaggio was exceptionally taken off the wall but did not leave Naples. It traveled up the hill to the Capodimonte Museum for the exhibition, *Caravaggio: L'Ultimo Tempo,* which gathered the maestro's works created during his final years in Naples, Malta, and Sicily. The show was so popular that a man who was under house arrest was caught waiting in the queue. The curators graciously sent him home with a catalogue.

A very good reason led President Leonetti to bend the founders' original mandate and let the painting be transported out of the church. The city agreed to fund the full restoration of Pio Monte's aged palace and smog-stained façade, the courtyard, and the church.

But when the exhibition flew off to London's National Gallery for the show *Caravaggio: The Final Years*, the painting did not leave the city. It returned immediately home to Spaccanapoli.

Long gone are the days when unsuspecting visitors stumbled past the church without knowing that a treasure hung inside. Now an elegant flag hangs under the archway of the palace announcing *The Seven Acts of Mercy*. Daily, streams of young and old purchase their tickets and pass through a side entrance to the church. Upstairs, the dim, dusty gallery is spruced up and brightly lit. The marvelous collection of paintings from the Neapolitan *Seicento*—all bequeathed by members

of the Pio Monte over centuries—gleams in its restored beauty for the viewing public.

Meanwhile, Angelo is no longer the guardian of the Caravaggio. He has been promoted and is now the supervisor of all the guardians appointed in the program of "Open Churches." He checks time cards, comings and goings, schedules, and leaves of absence. His wife Lucia and the family are steadfast and tighter than ever. All his girls have toasted him as a grandfather seven times over. Every so often, he returns as a prodigal son back to the Pio Monte to reconnect with the painting.

The renowned street teacher Marco Rossi-Doria served as deputy secretary of the Italian Ministry of Education from 2011 to 2014. He is now based in the Pio Monte, where he runs *Si Cambia*, meaning "we can change," his newly founded NGO created to empower street kids and Roma gypsies to become entrepreneurs. He receives funding from the *Fondazione con il Sud* and the Open Society Foundation of George Soros, with whom Marco shares Hungarian roots.

At the Orientale, Professor Adriano Rossi still teaches Achaemanid cuneiform, returning to Persepolis annually.

The literary visionary Richard Seaver and our friend Paola Caròla have departed from our lives, and their disappearance haunts us. I am deeply grateful to Dick, who lucidly offered me so much valuable advice, and the idea of using sliding doors to shift between past and present in this narrative. His memoir, *The Tender Hour of Twilight*, was recently published. Paola also finished her memoir about her friendship with Giacometti and his wife, Annette. She chose as the title the first words she spoke to the sculptor when she met him in Paris: *Monsieur Giacometti, Je Voudrais Vous Commander Mon Buste* (Mr. Giacometti, I Would Like to Commission You My Portrait).

Another great personality of Naples, the wonderful storyteller and art historian Giancarlo Alisio, has also departed, and so has the noble Professor Riccardo Sersale, former president of the Pio Monte, along with his adored brother Franco, another close friend of Paola's and ours. Positano will not be the same without Franco's eclectic spirit. Naples is poorer after their loss.

Since that memorable night passage to this millennium, when we were dancing in the explosive glow of colored flames of poetry lighting the skies of Naples, the world has vastly changed. The ecological stability of our planet is threatened for the first time in human existence. Wars and cruelty are corroding our ideals. Uncertainty governs our unconscious. But wonder and the magic of inspiration are invincible.

I say this because I wrote this story once before. But then, in the mountains of Indonesia, the entire manuscript vanished into the night. My laptop was stolen along with the backup drive. After a long period of mourning, Idanna shook me and insisted I should begin again, which eventually I did.

Ironically, this extended time frame allowed for the book to be released at a moment when the spiritual tectonic plates are shifting in Rome and beyond. Not only does the current Pope Francis inspire the faithful, he astonishes the world with his statements that he delivers with dramatic honesty and passion.

He strikes a deep chord.

Like Samson, he has shaken the temple. During his Christmas message to the cardinals, bishops, and priests that govern the Holy See, he delivered a scathing critique, reported by the *New York Times,* listing fifteen ailments afflicting them all:

> *The ailment of feeling immortal, immune, or even indispensable. Being rivals and boasting. Wanting to accumulate things. Having a "hardened heart" and "spiritual Alzheimer's." Wooing superiors for personal gain. Having a "funereal face" and being too "rigid, tough, and arrogant," especially toward underlings . . .*

Pope Francis is trying to take the Church back to those days that inspired Caravaggio, back to those early days when a barefoot carpenter's son spoke with humility and compassion, while living out the acts of mercy. He also speaks fearlessly. On a trip to Southern Italy, he drew a line in the sand, boldly condemning the feared Italian criminal organization known as the 'Ndrangheta. For the first time in history, a Pope banned the Mafia from the Church. "The 'Ndrangheta is this:

the adoration of evil and contempt of the common good. Mafiosi are excommunicated."

And when, in February 2015, he met with twenty newly appointed cardinals, he instructed them by citing the acts of mercy:

> . . . *See the Lord in every excluded person who is hungry, thirsty, naked; see the Lord in those who have lost their faith, or have turned away from the practice of their faith; see the Lord in who is imprisoned, sick, unemployed, persecuted . . . May we always have before us the image of St. Francis, who was unafraid to embrace the leper and to accept every kind of outcast. Truly the Gospel of the marginalized is where our credibility is found and revealed!*

Barely a month later, on Friday the 13th, he made another announcement: an Extraordinary Jubilee dedicated to Mercy. Jubilees are rare events in the life of the Church and ordinarily taking place every twenty-five years. Only two times before, in 700 years, has an "Extraordinary" Jubilee been declared. And never before has there been a special Holy Year dedicated to Mercy. Pope Francis did not consult any politicians in Rome or his own *Curia*, he simply announced it during mass, taking everyone by surprise.

Then came the groundbreaking encyclical, *Laudato Sí*, with his global message. His message is framed for each of us.

> *"Now, faced as we are with global environmental deterioration, I wish to address every person living on this planet and enter into dialogue with all people about our common home."*

His tender and powerful words speak of our beloved sister who "now cries out to us because of the harm we have inflicted on her by our irresponsible use." He poignantly describes the wounds of our *"Mother Earth"*—so violated, abused, laid waste—and in such need of our care.

> *"We have come to see ourselves as her lords and masters, entitled to plunder her at will. The violence present in our hearts, wounded by*

sin, is also reflected in the symptoms of sickness evident in the soil, in the water, in the air, and in all forms of life."

Openly rejecting the creed that "Man has dominion over Nature," he strikes a radically different tone. A true ecological vision, he insists, "must integrate questions of justice in debates on the environment, so as to hear both the cry of the earth and the cry of the poor."

And he speaks of our debt to future generations. "Intergenerational solidarity is not optional," he reminds us, "the world we received also belongs to those who will follow us."

The noted ecological author Bill McKibben called the encyclical "one of the most influential documents of recent times." The French philosopher Edgar Morin hailed the Pope's message as "a call for a new civilization."

Many wondered if his prophetic words would fall as seeds on rocky soil, or whether radical change was actually afoot. Whatever the future may hold, one thing was clear: his concern for the vulnerable poor lay at the heart of the matter.

On December 8, as dawn broke, St. Peter's "Holy Door"—the northern door usually cemented shut—swung open to welcome pilgrims for the coming year. As in past jubilees, all who passed through the portal would be forgiven. Yet, the Pope added a new twist. For those who could not afford the journey to the eternal city, he declared that basilicas and churches around the world would open their holy doors and offer the same grace granted to pilgrims at St. Peter's, the same blessings as in Rome.

And throughout the festive Jubilee Year of Mercy, one painting captured and symbolized Pope Francis's message of compassion and human solidarity.

The Seven Acts of Mercy.

Caravaggio would be pleased.

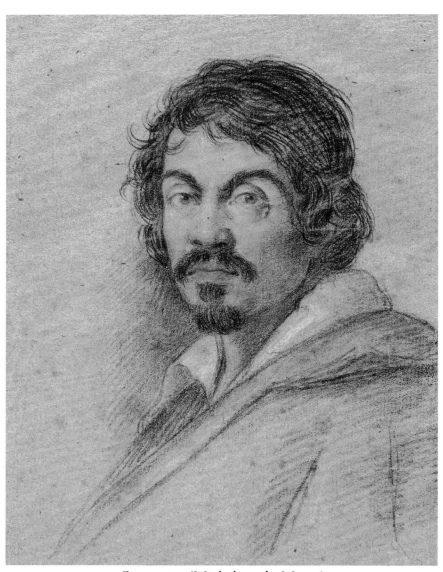

Caravaggio (Michelangelo Merisi)
Ottavio Leoni, 1621

The Palace of Pio Monte Della Misericordia, Via Dei Tribunali,
Naples

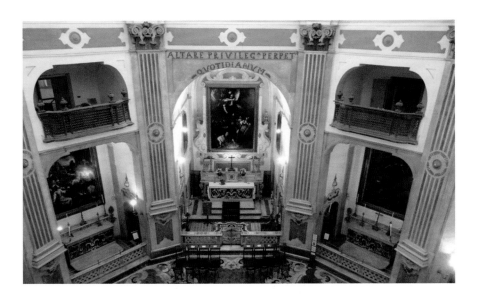

The interior of the Pio Monte Church with the Caravaggio altarpiece

Acknowledgments

This story could have never been written without Idanna's careful eye, sixth sense, and compassionate heart. She crossed the threshold on that first day and never looked back. As we plunged deeper, her feminine instinct and cool head ultimately offered another path for Angelo. And to this day, his family is bonded tighter than ever.

The late Bob Silvers, visionary editor of the *New York Review of Books*, brought Ingrid Rowland into our lives by commissioning a wide-ranging review about this book, two exhibitions, a play, the artist, and *The Seven Acts of Mercy*. It carried the poignant title: "The Virtuoso of Compassion." Ingrid highlighted Caravaggio's multifaceted humanity, revealing the true, universal nature of his art. The guardian, Angelo, was deeply moved.

In Florence, the Sri Lankan–born Canadian poet and novelist Michael Ondaatje opened a window for me when he delivered his *Lectio Magistralis* on a balmy June day at Palazzo Medici Riccardi. Michael spoke of *Mongrel Art*—art that reaches across the divide, that draws inspiration over the waters, and draws associations beyond one's own culture. He mapped out how Mongrel Art moves between forms—from painting into literature into film, from music into writing. I realized then that this book—along with my previous, *Searching for Hassan*—fell spontaneously into his "Mongrel" genre. After all, I am a mongrel too, raised in Arabia and Iran, then working in Greece and now living in Italy.

In New York, my gratitude goes to the late Richard Seaver, who founded Arcade Publishing with his inspired wife Jeannette. Both Dick and Jeannette saw what others could not. And I treasure Jeannette's continued friendship.

The first reader of my manuscript was the veteran New York journalist and Brooklyn literary icon, Pete Hamill, when he was researching a story that revolved around a lost Caravaggio in Sicily. Having been an artist himself earlier in life, Pete offered me keen insights about "Mr. C," as he calls him.

Elaine Pagels, Harrington Professor of Religion at Princeton, graciously spoke at the book launch in the National Arts Club and offered her views about Matthew 25. She called it the "jewel of the New Testament." My "brother," Dr. William Vendley, secretary general of Religions for Peace, the world's largest interfaith organization, also joined her on the podium that evening.

My special thanks go to Stefano Albertini, director of Casa Italiana Zerilli-Marimò of NYU, who was a fan of the story at the outset and hosted a moving presentation sharing the auditorium stage with his co-conspirator, Professor Pellegrino d'Acierno, director of Italian studies at Hofstra. Their passionate words I carry with me.

In New York, I also salute my sister-in-arms Duff Lambros who was so moved by the painting that she pursued her chaplaincy degree so she could perform the acts of mercy in her city. Her friend, Father Andrew Small, also helped the story spread its wings in both America and Italy.

In San Francisco, my heartfelt thanks goes to two literary "passionarias," Judge Kathleen Kelly and Mary Letterii. I also salute Governor Jerry Brown for his great gift of wisdom and his Illichian conviviality.

In Rome, I am grateful for the solidarity of Cardinal Kodwo Turkson and Father Michael Czerny and their invitation to speak at the Vatican Press Conference on September 1, 2016, announcing Pope Francis's Eighth Act of Mercy, "Care for our Common Home," our Mother Earth. A month later, across the city, in Piazza del Popolo, Don Walter Insero—the rector of the Basilica Santa Maria in Montesanto known as the "Church of the Artists"—hosted a presentation. And the

film director Liliana Cavani shared her profound words about what she calls "Caravaggio's theology."

In Naples, I send a warm embrace to Marco Rossi-Doria, known as the "maestro of the street" and the courageous and illuminated Don Antonio Loffredo, the parish priest of the Basilica Santa Maria della Sanità, an extraordinary place, which everyone should visit.

I remain deeply indebted to Gianpaolo and Maria Grazia Leonetti di Santojanni for their trust and friendship, and also to the art historian Loredana Gazzara, director of the Pio Monte historical archives. Finally, I wish to express all my gratitude to the current leadership of Pio Monte della Misericordia:

President
Barone Alessandro Pasca di Magliano

Vice President
Nobile Donna Fabrizia Paternò dei duchi di San Nicola

Governors
Nobile Raimondo Zampaglione

Marchese don Giuliano Buccino Grimaldi conte di Bisaccia

Nobile don Luigi Pietro Rocco dei principi di Torrepadula

Nobile don Roberto Dentice di Accadia dei conti di Santa Maria Ingirsone

Nobile Emma Garzilli Fiore dei conti Garzilli